NO EXPERIENCE REQUIRED!

SKeTCHiNG and DRaWiNG

D1318521

NO EXPERIENCE REQUIRED!

SKeTCHiNG and DRaWiNG

Larry Blovits

NORTH LIGHT BOOKS
CINCINNATI, OHIO
www.artistsnetwork.com

About the Author

Larry Blovits is an award-winning, nationally known landscape and portrait artist. He has been an elected signature member to many art organizations, including the Portrait Society of America, American Society of Portrait Artists, the Salmagundi Club and the Pastel Society of America (New York City). In 1993, the Pastel Society of America honored Larry with the title of Master Pastelist.

Receiving his Bachelor and Master of Fine Arts degrees from Wayne State University in Detroit during the mid-1960s, Larry went on to become a full-time professor at Aquinas College in Grand Rapids, Michigan, where he taught basic drawing, anatomy and life drawing, and painting for twenty-six years until retiring as professor emeritus in 1993 to pursue his personal artwork on a full-time basis. Known as a dedicated and caring instructor, he has been teaching workshops internationally since the mid-1970s and continues to share his extensive knowledge with students of all ages.

He is the author of *Pastel for the Serious Beginner* (Watson-Guptill) and is featured in a number of other books, such as *Pastel Interpretations* and *The Best of Flower Painting* (North Light Books), *The Art of Pastel Portraiture* (Watson-Guptill) and *The Best of Pastel 2* (Rockport Publishers). Larry is also a contributing editor to *Pastel Journal*, *International Artist* magazine, *The Artist's Magazine*, and *American Artist* magazines.

Larry can be contacted by e-mail at blovits@kvi.net or by regular mail at O-1835 Luce S.W., Grand Rapids, MI 49544.

No Experience Required: Sketching and Drawing. Copyright © 2004 by Larry Blovits. Manufactured in China. All rights reserved. No part of this book may be reproduced in any form or by any electronic or mechanical means (including information storage and retrieval systems) without permission in writing from the publisher, except by a reviewer who may quote brief passages in a review. Published by North Light Books, an imprint of F+W Publications, Inc., 4700 East Galbraith Road, Cincinnati, Ohio, 45236. (800) 289-0963. First Edition.

Other fine North Light Books are available from your local bookstore, art supply store or direct from the publisher.

08 07 06 05 04 5 4 3 2 1

Library of Congress Cataloging in Publication Data
Blovits, Larry
 No experience required : sketching and drawing / Larry Blovits.
 p. cm.
 Includes index.
 ISBN 1-58180-505-5 (pb. : alk. paper)
 1. Drawing--Technique I. Title.

NC730.B544 2004
741.2—dc22 2004040620

Edited by Bethe Ferguson, Gina Rath and Mona Michael
Production edited by Mona Michael
Art direction by Wendy Dunning
Design and production art by Barb Matulionis
Production coordinated by Mark Griffin

METRIC CONVERSION CHART

To convert	to	multiply by
Inches	Centimeters	2.54
Centimeters	Inches	0.4
Feet	Centimeters	30.5
Centimeters	Feet	0.03
Yards	Meters	0.9
Meters	Yards	1.1
Sq. Inches	Sq. Centimeters	6.45
Sq. Centimeters	Sq. Inches	0.16
Sq. Feet	Sq. Meters	0.09
Sq. Meters	Sq. Feet	10.8
Sq. Yards	Sq. Meters	0.8
Sq. Meters	Sq. Yards	1.2
Pounds	Kilograms	0.45
Kilograms	Pounds	2.2
Ounces	Grams	28.3
Grams	Ounces	0.035

Acknowledgments

My thanks to the assistance and patience of my editors at North Light Books, Bethe Ferguson and Gina Rath, and for the encouragement and proofreading of my wife, Linda. Their help was much appreciated.

Dedication

I'd like to dedicate this book to all my former professors, who provided me with a sound education, provoked a curious mind and helped me to develop patience, dedication and perseverance. Equally important are the students I've taught and learned from. I'd also like to dedicate this to all those I love, who have loved me in return for who I am. Each and every one has been a factor in shaping my life and my career in education and art. Thank you all for your kind and generous input. I am eternally grateful.

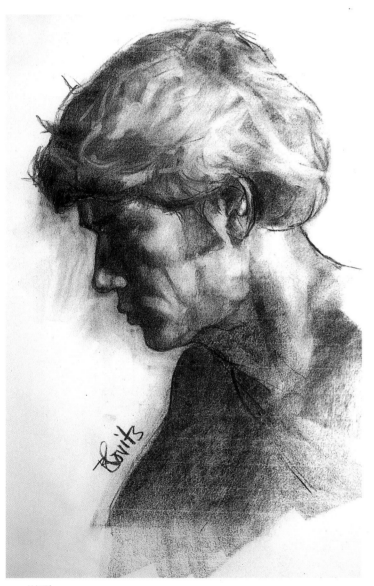

NATE
Charcoal
22" x 17" (56cm x 43cm)
Collection of June Horowitz

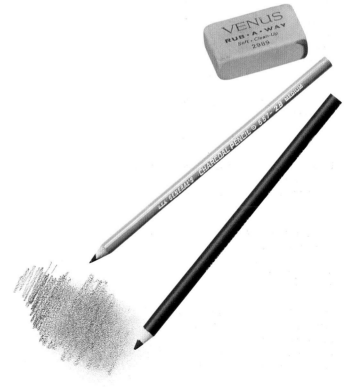

Table of Contents

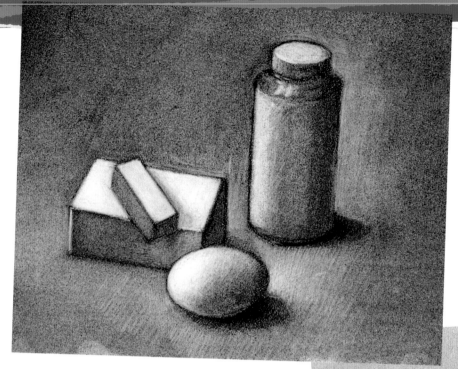

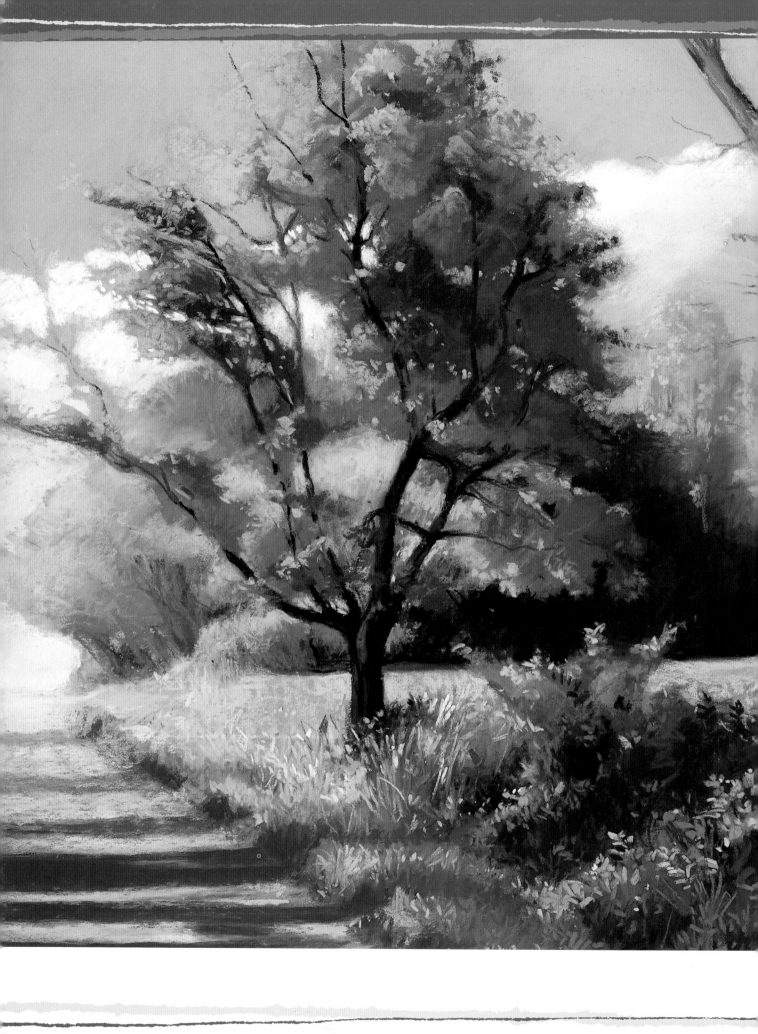

Introduction

This book is an introduction to the physical and technical aspects of drawing mediums, drawing surfaces, useful tools and equipment, techniques and procedures, and the fundamentals of light, volume, and depth used to create a drawing.

For the beginner, the easiest drawing tools to learn with are pencil and charcoal because each has only one inherent characteristic: *value* (the relative lightness or darkness of the medium against the surface). The next step in our drawing progression is to use Conté crayon with its added characteristic of simple color. The final chapter involves working with pastel, which introduces additional characteristics an artist must consider.

Each chapter presents technical information about the drawing medium and encourages you to gain experience and facility through step-by-step exercises that progressively build on the skills acquired from the previous chapters. By discovering the characteristics and idiosyncrasies of each drawing medium, you'll learn how to use each drawing tool with a variety of textured surfaces.

An artist creates an illusion of a still life, landscape or figure. This illusion is made possible through a complete knowledge of drawing tools, techniques, materials and surfaces, and the traditional fundamentals used to portray light, form and depth.

The purpose of this book is to make you aware that you can learn how to draw. This book will start you on your way to the joy of discovery and the ability to create drawings that make a statement. Research, reinforcement, practice and instruction will make it all possible. You can learn to draw!

DOWN A COUNTRY ROAD
Pastel on sandpaper
11" x 14" (28cm x 36cm)
Collection of the artist

Pencil

encil is one of the easiest tools to learn to draw with. Nearly everyone is familiar with pencils because they are used for different functions in everyday life. For example, the no. 2 pencil is used for filling out forms and taking tests. Pencils are also ideal for sketches, detailed illustrations, figure work and portraiture—although more complex drawings require a set of special drawing pencils.

The best thing about using pencil is that you have only one characteristic to deal with: *value*. Value is the relative lightness or darkness of a color, tone or shade. Later, we'll discuss charcoal, Conté crayon and pastel. These mediums have additional characteristics that make them a little more complex to use. Once you understand value, however, drawing becomes easier, and you can learn a lot about value with just a pencil.

Use the shopping list to gather the materials you'll need throughout this chapter.

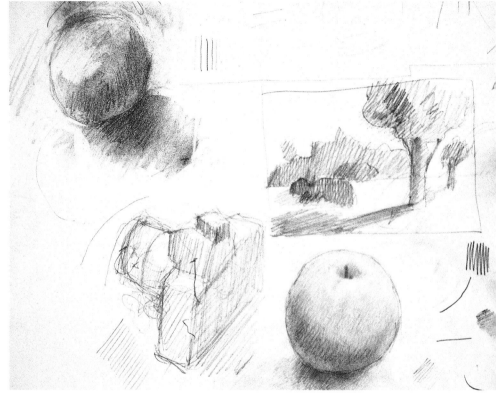

Sketchbook Practice Page
As you learn to draw, keep a sketchbook on hand to practice your new techniques.

SHOPPING LIST

PAPER
Sketchbook—good quality, smooth finish

PENCILS
4H, 2H, H, HB, 2B and 4B

OTHER
Soft pink eraser • Kneaded eraser
Soft white eraser • Electric pencil sharpener
Hand-held pencil sharpener • Sandpaper block
Value scale

Pencil Pointers

Every artist should invest in a set of pencils with both hard and soft leads to meet different artistic requirements.

Lead (graphite) variations are available in a full range, from very hard to very soft. Numerical designations indicate either increasing hardness or increasing softness, depending on the series. Thus the H (hard) pencil series begins with H at the softer end and progresses through 9H at the hardest end, while the B (soft) series begins with B at the harder end and progresses through 9B at the softest end.

Understanding the characteristics of each pencil series will help you achieve the variation of pencil marks you need. The H, HB and 2B are the pencils you'll use the most, but it is important to know the characteristics of all the pencil types.

Pencil Varieties

B or soft-lead pencils produce a wider range of values (variation from light to dark) than hard-lead (H) pencils. The soft lead naturally produces dark marks, therefore it is more difficult to achieve light values with these pencils. They also require sharpening more often than the H series. Use light pressure when using the softest B pencils, such as 4B to 8B, to avoid creating indentations and graphite shine on your paper.

The H series or hard-lead pencils has a subtle and limited value range. They create lighter marks or a lighter range of values and can't produce the dark values that softer leads can.

In addition to pencils, you can use graphite sticks, which are pieces of solid graphite without an outside covering. These work for broad and general sketching, but you won't be able to accomplish many of the exercises that call for detailed marks. The edges become round with continued use and there's no way to sharpen the stick. Use drawing pencils for our initial exercises.

You'll also need a way to keep your pencils sharpened at all times. An electric or battery-operated pencil sharpener does an excellent job. A high-quality hand-held pencil sharpener will work just as well, but isn't as convenient. A sandpaper block can sharpen the pencil to a finer point and helps keep the pencil sharp while the drawing is in progress.

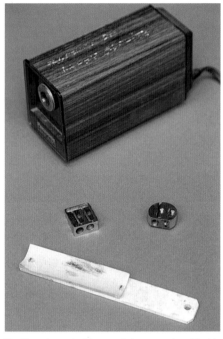

You'll want an electric pencil sharpener, hand-held sharpeners and a sandpaper block to keep your pencils sharp and ready for every technique.

Graphite sticks come in many sizes and shapes. They are useful for creating large tonal areas.

For the beginning artist, I recommend the most useful range of pencil leads: 4H, 2H, H, HB, 2B and 4B.

Drawing With Pencil

How hard or how softly you push on the pencil when drawing is the *application pressure*. Knowing how much pressure to apply when drawing is a very important skill to develop. You can produce a light, delicate line or a very forceful, dramatic line depending on the amount of pressure you apply.

Each pencil lead, whether hard or soft, has an *aesthetic range*, which is the rich and beautiful variety of marks possible with each lead type. Soft pencils (B) have a greater aesthetic range than hard pencils (H). To discover the aesthetic range of each pencil lead, start with the lightest application pressure and gradually increase to the strongest pressure, stopping just before incising the paper.

If you push beyond the aesthetic range of a particular pencil type, the paper becomes dented and a phenomenon known as *graphite shine* will appear. This shine will be more obvious in the soft (B) pencils than in the hard (H) pencils. It occurs when you press too hard on the pencil when trying to make the marks darker. Avoid pressing too hard or you will mar the paper and create this unattractive shine.

Experiment with each drawing pencil to familiarize yourself with its aesthetic range. Begin with the highest number in the H category (4H) and draw a line starting with the lightest pressure to produce the lightest possible value. Gradually increase the pressure as you extend the line, stopping before the pressure mars the paper. Repeat this simple exercise with each pencil type (4H, 2H, H, HB, 2B, and 4B).

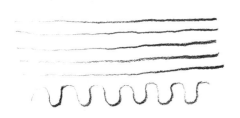

Experiment with Application Pressure
See what you can do by varying the pressure on your drawing tool as you create line.

Aesthetic Range
Being sensitive to the aesthetic range you produce by pressure change increases what you can create with each pencil type. That's a real asset.

Learn to Avoid Graphite Shine
Create graphite shine by pushing hard enough to create a solid tone and dent the paper. This will show you what *not* to do when drawing.

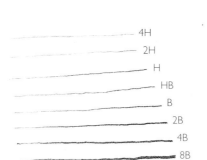

Discover the Aesthetic Range
Starting with the lightest touch, gradually increase the pressure until you discover the entire aesthetic range of that pencil type.

Drawing Methods

Drawing knowledge is cumulative; what you learn in one medium is transferable to other mediums. There are three ways to create compositions with any drawing medium: *additive*, *subtractive* and *additive-subtractive*. You will use each of these methods in this book.

Additive

With the additive method, you apply the drawing medium to the paper in successive layers to create the drawing. Layering increases the density (opacity) and can darken the value. You create the image by hatching and crosshatching, using different pressures and by layering tonal values.

Subtractive

In the subtractive method, you create a middle-value base and then remove parts of it using your fingertips, erasers or a chamois. The initial base creates a *translucent* ground, where the white of the paper is part of the value produced. As you subtract the ground, you're actually removing part of the top layer and allowing more of the white paper to show through.

Additive–Subtractive

The additive-subtractive method combines both the other methods to develop a more detailed drawing.

WORDS TO KNOW

BRIDGE A piece of paper or another material placed between the hand and the drawing surface to keep the drawing clean and prevent smudging.

Keeping Your Drawing Surface Clean

You'll want to keep your drawing clean and prevent smearing, which produces a flat, dull-looking tone and negates whatever drawing characteristics you're trying to make or retain. Be careful not to ride the heel of your hand over your drawing as you draw, as it will smear. Artists often place another piece of paper, or a *bridge*, between their hands and the drawing surface to keep their drawings clean.

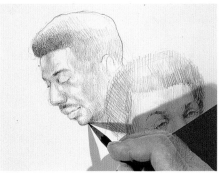

Prevent Smearing
Any piece of paper placed between your hand and the drawing will help to keep your work clean and unsmeared.

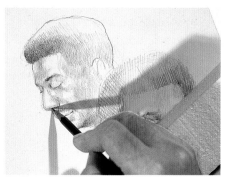

A Bridge
You can use a variety of materials for a bridge, such as Plexiglass, Styrofoam or a piece of wood.

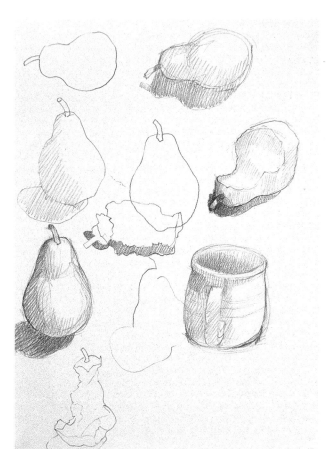

Sketchbook Exercises
Keep a sketchbook for practicing your drawing. Not every drawing has to be a perfect work of art. Learning to draw comes from practice, so practice a lot and don't worry about making mistakes. Quantity leads to quality—the more you draw, the better you'll become. There are no shortcuts.

The Value Scale

The word *value* refers to the relative lightness or darkness of a color, tone or shade, from the very lightest (white) to the darkest (black). You can buy a value scale at most art stores. Use the scale to compare and match the values of your drawing subject to the values in your drawing. This aid helps you to become more accurate in seeing and reproducing the correct value.

Being able to identify the values of an object and to recreate those same values in a drawing is a skill every artist must acquire. This is something you can learn too. The ability to match values will prove to be a valuable and necessary function for all of your drawings.

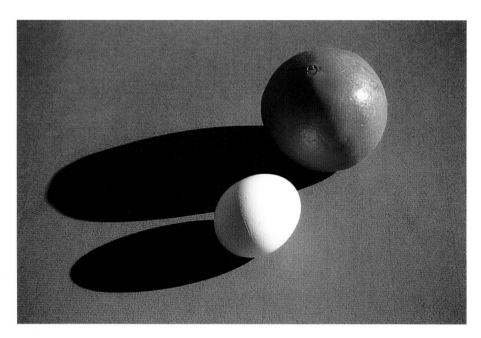

 WORDS TO KNOW

VALUE The relative lightness or darkness of a color, tone or shade. This includes the range of black to white and all the shades of gray in between.

VALUE SCALE A tool that indicates gradations of tone from the lightest to the darkest.

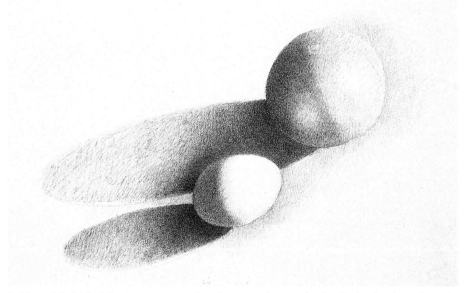

In this partially finished drawing, you can see how I attempted to match values in the drawing to the real objects. Obviously, I still have more work to do.

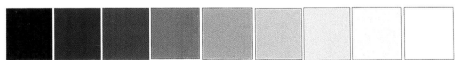

Value Scale

Keep Your Pencils Sharp

When you select a paper to draw on, keep in mind some key facts. Paper is composed of tiny fibers interlocked and overlapped in multiple directions to form a drawing surface. Paper is manufactured in different textures from smooth to rough, and each type has a different surface. Every paper has texture, but it's much more evident in the rough variety.

This is why it's important to keep your pencils sharp when drawing. A dull pencil with a blunt, flat end will ride on the top grain of the paper, depositing graphite only on the upper-most part. It won't touch the lower surface or valleys of the paper's texture. This will produce a dull-looking line.

A sharp point reaches both upper and lower surfaces and produces a higher quality line that is consistent in tone. Keep your pencils sharpened at all times and your lines will have more vitality and variety. And remember, softer pencils need to be sharpened more often.

In general when working with pencil, select a smooth paper where the grain is less evident. Smoother paper doesn't show the grain as readily as a rough surface, so you'll achieve a more consistent tone.

Sharpness Is an Advantage
Unlike a dull pencil, a sharp pencil can reach the lower part of the paper texture. Also, a sharp pencil can create a multitude of characteristics that a dull pencil cannot.

Rough Paper Means Extra Work
As you can see by the illustration, rough paper readily produces an uneven texture, which then requires you to do extra work in order to control the surface.

Hatching and Crosshatching

Hatching is a series of lines, usually parallel, placed close together and used to build shape, texture or shade. You can make the value of each line exactly the same as the last or vary it to create different effects.

Crosshatching is similar to hatching except now the lines cross each other to create a wider set of marks. Crosshatching enables you to increase the density and darken value in small, incremental layers. This is a great tool to create form and shadow. It is very versatile and expressive. You'll find out just how important this is later in the book.

Hatched lines similar in value, length and spacing are visually perceived as a mass unit of value.

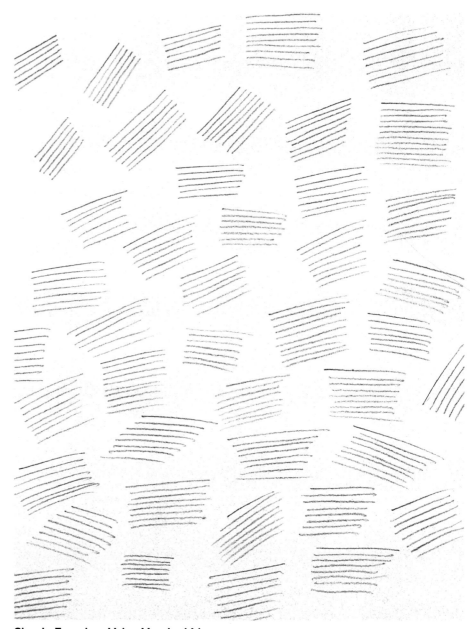

Change the Angle
Create the crosshatched layer by changing the angle of new lines and the shape of the openings between them. Make every line exactly the same value as the preceding line. Don't darken or lighten the value.

Simple Exercises Using Hatched Lines
Try creating a number of hatched units. Try to keep the values exactly the same and the lines at equal distances from one another. Practicing this will provide many benefits and will help develop your drawing skills. Have patience and cover your sketchbook page with many examples. Practice is very important.

Each Layer is Darker

Each successive hatched area appears a little darker in value than the preceding layers. Equal pressure is your key to success in this exercise. The value deepens simply as the additional layers are applied with equal pressure, not from applying more pressure to create a darker line.

Sketchbook Exercises

Create a number of crosshatched masses to see what two layers look like, then three, four and so on. Build an area with up to ten layers to see what it looks like. You will acquire insight and expertise as you physically and visually work through each exercise.

Again, cover the sketchbook page with many examples while you continue to build your skills. Remember, equal pressure creates a consistent line value.

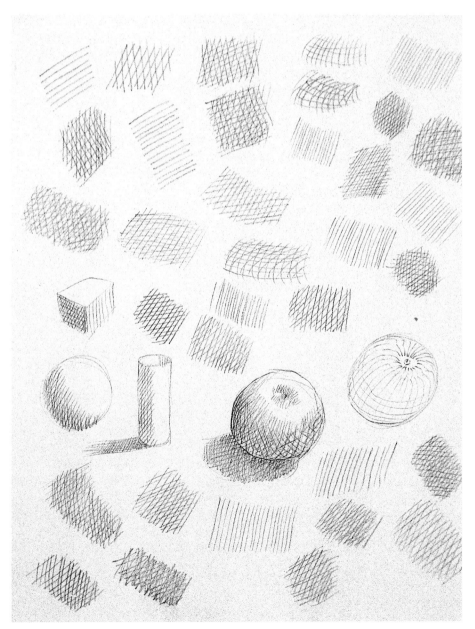

WORDS TO KNOW

HATCHING A series of lines, usually parallel, placed close together and used to build shape, texture or shade.

CROSSHATCHING Similar to hatching except now the lines cross each other to create a wider set of marks.

Contour Lines

Contour lines represent outlines or any other defining edges. When you backlight an object, you'll see its silhouette edge. That's a contour line. The contour line provides information as to what the object is or may be in its simplest form.

Defining lines within the outside border are also considered contour lines (such as a lapel edge on a jacket). Drawing accurate contour lines will help you create the right descriptive configuration, another valuable asset in your artistic repertoire.

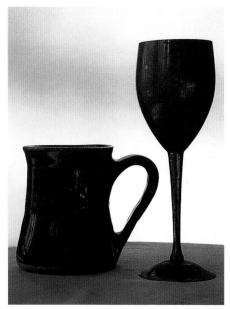

Contour Edge

The silhouetted edges of these backlit objects are considered the contour edge.

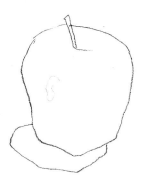

Draw a Continuous Contour Line

When drawing a simple form like an apple, draw the outside edge with a single, continuous line. Repeat this exercise over and over until your drawing exactly duplicates the apple's contour.

Don't be discouraged if the first drawing doesn't match the object exactly. Drawing an accurate contour line takes time and requires you to look intently at your subject. Take heart; you're learning how to see artistically.

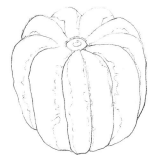

Outside Edges

This line is commonly thought of as the outside silhouette, border or contour. When drawing, faithfully create every twist, change and subtlety as precisely as you can. This provides critical information to the drawing.

Inside Edges

There are numerous edges within most objects. The edges of the squash are both the outside contour (silhouette) and the inside contours (seams, furrows and edges of the different color masses in those furrows). All these contours, both inside and out, define the squash.

QUICK TiP

Avoid sloppy or inaccurate contours. They don't contribute anything positive to the drawing, only visual confusion.

Work Up to the Challenge

When you have success with simple objects, move on to one slightly more difficult, such as a flower. Draw only the outside contour with a single, continuous line. Draw the same flower again until you succeed in getting a likeness. At this point, just concentrate on the outside contour.

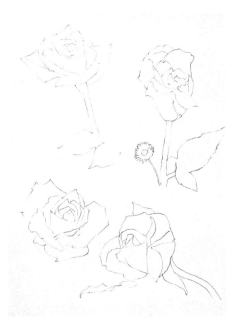

QUICK TIP

Work slowly on this type of drawing. It requires concentration and patience, but it also adds more information to the drawing.

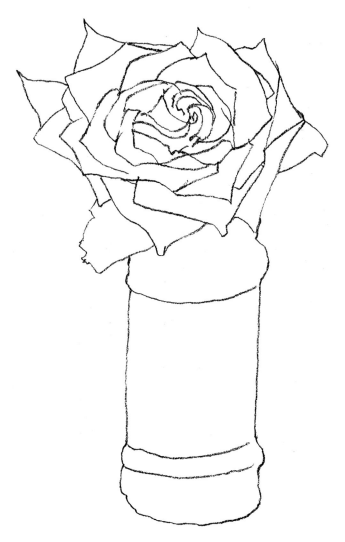

Fill Some Sketchbook Pages

Fill at least a couple of sketchbook pages with contour drawings—the more the better. Remember to look at the subject's defining lines when you draw. If you see a value change in the contour, record it as accurately as you can by varying the pressure on your pencil. Give your best effort on the first drawing, then move on to the second drawing of the same object, then the third, and so on. Each successive drawing will improve as you continue to look carefully and patiently at your subject.

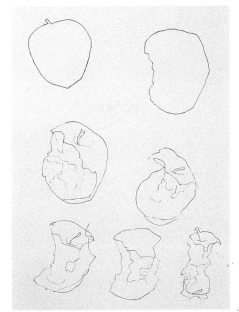

Sketchbook Fun

I first drew the outside of this apple and, after each bite, included the inside contours in each successive drawing. I guess I shouldn't draw when I am hungry!

Keep Practicing

Look around your house for simple objects to draw. Choose objects with good, visible contour edges. I chose a rose resting in a container. You can copy my drawing or choose one of your own later.

Take your time and record every contour you see. It doesn't have to be perfect; just get the basic lines down. When you're able to draw all the lines accurately, give yourself a pat on the back! You've already acquired some of the necessary skills of the artist.

Blind Contour Drawing

A *blind contour* drawing is similar to a contour drawing except that you look at your subject 100 percent of the time without looking at your paper or lifting your pencil. That's why it's called *blind*.

Most people are anxious to see what they're drawing, but this is an important exercise in training your eye and hand to work in perfect harmony. This will help you produce better drawings later. Be patient and take it slowly as you coordinate the movement of your eye with the same slow movement of your pencil point.

Draw only what you see; don't make anything up. Record every change in direction, value and texture. If the line appears strong, push harder; if weak, let up on the pressure. Make decisions as you draw and don't rush. Notice things like the texture, strength, elegance and direction. By taking the focus off the drawing itself, you are learning to really observe and see.

Use blind contour lines to draw objects, moving gradually from simple to more complex forms and structures. Fill at least five pages in the sketchbook with this exercise.

Blind contour drawing is just one more aspect of the drawing experience. By completing these simple exercises, you're continuing to add to your drawing repertoire. Besides becoming more sensitive and perceptive, you're learning how to see like an artist.

WORDS TO KNOW

CONTOUR LINE An outline or defining edge.

BLIND CONTOUR DRAWING A contour line drawing done without looking at the paper or lifting the pencil while drawing.

A

B

Don't Fret
Some of your drawings may not resemble your subject at all! Remember, you're just drawing the contours that create and tell a story about the object. As you continue this exercise, you'll get better at coordinating the length of the line with the slow movement of your eye.

Compare
Compare drawing A, where I looked back at the paper, and drawing B, where I didn't. The lines on drawing B are exciting and varied, not dull and repetitive.

Don't Give Up

If you look back at your page while drawing, stop the line where you were when you stopped looking at your subject. Place your pencil point on the spot where you stopped and look back at your stopping point on the object. When your concentration is once again at 100 percent, start your eye and pencil moving again.

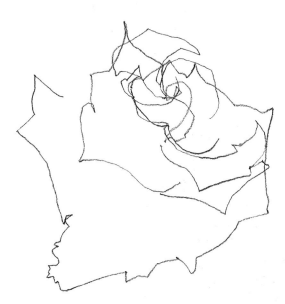

A Sketchbook Page

I made these blind contour line drawings of random objects to test my observation skills.

Blind Contour Takes Patience

Select a complex object in nature, such as a flower. Place your pencil in the middle of your paper. Choose a starting point on the edge of the flower and concentrate until you imagine the pencil point is actually on the flower. Begin very slowly and coordinate the movement of the pencil with the movement of your eye, recording everything you see as you slowly move along the contour.

When you come to an intersection of edges, pick one and move your eye slowly along the new edge, recording characteristics as you see them. Follow the edges of the flower until you run out of a linear edge. Then look at your paper. Don't be surprised or upset at what you see. Blind contour drawings often look odd or misshapen.

To continue to develop the drawing, place the pencil point at the point where you stopped and look back at the same intersecting point on the flower. Concentrate and begin drawing a new line, taking alternate routes as you find them. Record the changing characteristics of the line as it travels over a variety of texture surfaces. Move slowly. Your eye doesn't see anything if it moves too quickly. It takes time and practice to precisely record what you see.

Cross-Contour Lines

A *cross-contour line* (or surface line) is any real or imaginary line that conveys surface direction and the structural form of an object. These lines do not define inside or outside edges; rather, they are used by artists to further describe form.

Imagine picking up an apple and tracing your pencil around its surface in parallel lines. The lines would wrap around the curves of the apple in the same way that latitudinal lines encircle the globe, clearly indicating the its round form.

Intersecting cross-contour lines are an additional (but not parallel) layer of cross-contour lines placed on a subject to provide additional surface information.

Surface cross-contour lines help describe the volume of the forms.

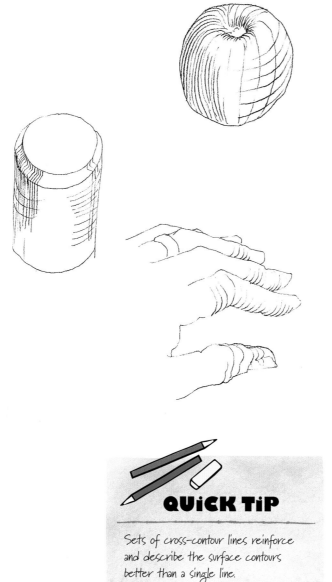

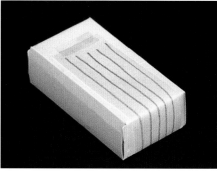

Discover Cross-Contour Lines
Draw parallel lines on a piece of paper. Cut out the lines and paste them around a simple box, such as a box that photographic slides come in (or any cardboard box you have around the house). The cross-contour lines mimic and define the surface directions of the top and side planes.

QUICK TIP

Sets of cross-contour lines reinforce and describe the surface contours better than a single line.

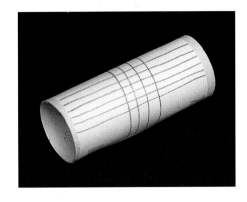

WORDS TO KNOW

CROSS-CONTOUR LINE A line on the surface of an object that indicates direction and structural form.

Try This

Use the same set of parallel lines as in the previous illustration, but add five new lines that intersect them at right angles. Place this example over a cylinder with one set parallel to its lengthwise axis and the other set wrapped around its body. Notice how the straight lines along its length suggest a flat side but the other lines indicate a curve or rounded form.

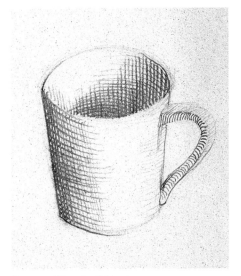

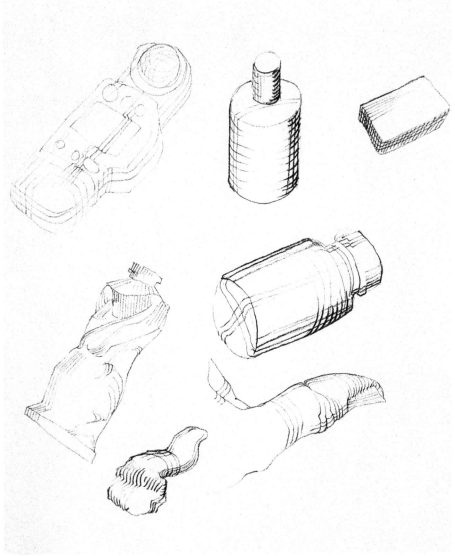

Draw a Simple Object

Take a simple object, like a coffee cup. Draw the object using contour lines to create the outline and inside edges. Add sets of cross-contour lines to describe its form. Create parallel lines where the surface is flat and curved parallel lines where the surface is curved. Allow the lines to cross where necessary.

A Sketchbook Page

Fill at least five sketchbook pages with drawings that use cross-contour lines. Don't worry if the first ones don't look right. The main idea behind keeping a sketchbook is to practice. You'll improve and become more familiar with the function and use of cross-contour lines with each new drawing. You'll be amazed and pleased at the difference practice makes!

Gesture Line Drawing

Not all drawings are done with precise contour lines made with the sharp point of a drawing implement. Some images are created with an energized swipe of the drawing tool to connote a sense of movement. These quick, energetic drawings are called *gesture drawings*.

A gesture drawing captures the essential energy, action or activity of the subject rather than what the subject is. These are completely different from all the line drawings we have viewed previously. Gesture drawing is the unrestricted beginning investigation of the subject matter.

Gesture drawings should take only a few seconds. If you start thinking about what the subject is and analyzing how it should be drawn, you are no longer creating a gesture drawing.

For example, if a ball falls off a ledge, you would draw the downward movement or action, not the ball. The ball would be in motion (the gesture) and would be a blur. Remember, it's a quick glimpse, not an in-depth study.

Gesture drawing is often used as a warm-up exercise when beginning to draw. Once you get the basic gesture you can gradually include the other processes and techniques you've already learned.

Gesture Line Drawing of Camera

This drawing is just a quick response to the camera. It doesn't have to look exactly like a camera, you just want to show the movement or essential energy of the subject rather than its specific form.

WORDS TO KNOW

GESTURE LINE DRAWING
A quick line drawing that indicates energy, action or motion, rather than specific form.

Practice Gesture Line Drawings

Create a multitude of gesture drawings using both animate and inanimate objects. Place your pencil point on the page, look at the object, and respond instantly with one continuous line. Don't think about how to draw the object—just respond.

Once again, don't be discouraged by what this type of drawing looks like. After all, you're drawing what the object is doing—the action or essential energy of the object—rather than what it is. It's meant to look abstract.

These are examples of gesture drawings from my sketchbook. You probably can't tell what they are, but you can see the energy in each drawing. And this energy is what you are striving to represent.

Blending and Rubbing

Blending and *rubbing* are used to create tonal value variations or gradations. Both can be accomplished by rubbing graphite lines with your fingers, a paper stump, a rag or a chamois.

Blending requires a delicate, sensitive touch so you can smooth out tonal areas and fill in open pores in the paper without damaging the surface or the quality of the medium. Areas toned with pencil or any other drawing medium may be blended to create a fairly solid value mass, which you still draw on. A solid tonal area genearlly makes a stronger statement than a hatched or cross-hatched area.

Gentle blending with your fingers or other blending tools retains the texture of the surface and the vitality of the application. Rubbing, on the other hand, is less delicate than blending. Rubbing involves using sufficient pressure to completely fill the pores of the paper and compress the tonal masses into one value. Hard rubbing, also called burnishing, flattens the texture of the paper. If done too harshly, rubbing can damage the surface and negate the characteristics of the drawn line, so rub carefully and only when necessary.

Throughout this book, you will learn more about the different purposes of blending and rubbing, and the results that can be achieved when these techniques are applied to the various drawing mediums.

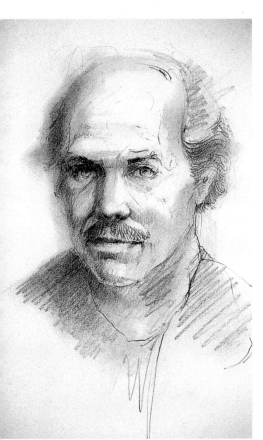

Rubbing Results
After laying down my initial contours and hatching, I rubbed the entire drawing to convert everything into a solid tone and produce a foundation for the next layer. Rubbing eliminated my initial individual lines and made those areas very passive. Erasing certain areas produced a feeling of light, shade and volume. Adding descriptive lines in the foreground helped to clarify that area. Notice how the least developed areas recede and the more developed areas come forward.

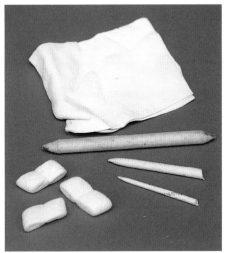

Rubbing Technique
Draw a series of hatched lines with a soft pencil, such as a 4B. Rub this area with your fingers. If the area doesn't go dark enough, lay down another layer of hatched lines and rub again. Notice the results. The lines are suppressed, eliminated or flattened into a solid tone. You've also eliminated the white value in that rubbed area.

Blending Tools
You can use a variety of tools to help you create different blending effects. Try using your fingers, a paper stump, a tortillion, a rag or a chamois.

WORDS TO KNOW

BLENDING The process of smoothing and combining pencil marks or other mediums to create variations or gradations in value.

RUBBING OR BURNISHING Blending with enough pressure to flatten or damage the texture of the drawing surface.

CHAMOIS Soft leather cloth for removing or blending charcoal or pastel.

TORTILLION Blending tool made of soft rolled paper.

PAPER STUMP Blending tool made of compressed paper.

To Rub or Not To Rub

This exercise will allow you to see and experience the difference in creating a drawing using crosshatching without rubbing, then again with rubbing. Be sure to use a cover sheet or bridge to keep your hand from smudging your drawing.

1 Create a Contour Line Drawing

Choose a simple object to draw, such as a tomato. Begin with a contour line drawing using an H pencil and light pressure (as you practiced on page 18).

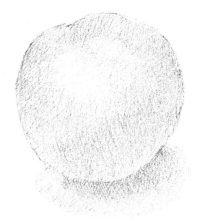

2 Hatch In Values

Hatch and crosshatch until you approach the approximate value of the tomato. Use the value scale to compare the lightness and darkness of the object to your drawing to see if they match. Keep the same pressure throughout the buildup of the drawing. Gradually switch to B and 2B pencils to create darker values in the darker areas. Rather than increasing the pressure to darken the value, keep hatching and crosshatching. Remember to keep your pencil sharp at all times.

3 Continue to Darken Values

Continue crosshatching to darken the values. It may take 10 to 15 layers of crosshatching to get the correct values. After a certain number of hatched layers, the top random fibers of the paper become apparent and start to become darker simply because the pencil is riding on top and not touching the fibers below. This is the point where a tonal mass is created.

Try not to touch the darker areas again, but instead use a sharp pencil point to fill the openings with the same value. If successful, the former "dark" lines will disappear and become part of the tonal mass.

4 **Continue Hatching**
Add another layer of hatching using a very sharp pencil and delicate pressure throughout. The more you can fill the porous openings, the darker the value. You will need many additional layers to get to this stage. Be patient; you are creating a beautiful rendering.

5 **Final Layer**
With the sharp point, fill in the openings and bring the values to a unified tone so you can control the value transitions and complete the drawing.

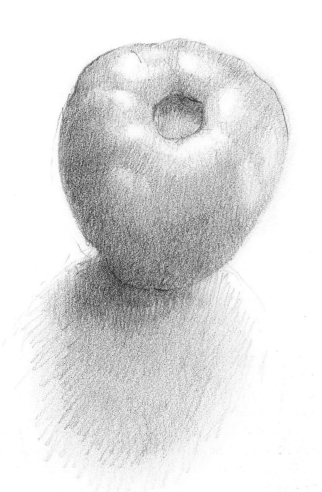

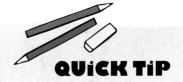

QUICK TIP

- One pencil can't do it all. Choose a softer pencil, such as a 2B or 4B, for darker values and harder pencils, 2H or 4H, for lighter values.
- Start with the darkest value in the darkest area and gradually lighten as you work into the lighter areas. Gradual changes in value add to the feeling of volume.

Use the Rubbing Method
Draw an apple using the rubbing technique as shown on page 25. Once you have finished the drawings using the two different methods, step back and see which drawing you like the best—the rubbed or unrubbed. Why? Forget about which drawing took the longest; just make your decision based on what looks best.

Combining Lessons

It's time to put together all the lessons you have learned so far. Set up a still life using one object, such as an apple. Place a desk lamp or other light source nearby so you can see its effect on the the shaded side of the form along with the cast shadow. For more information about light sources, see page 42.

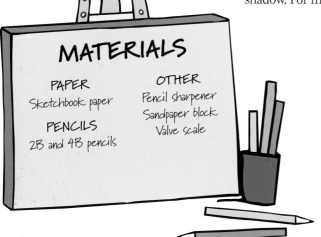

MATERIALS

PAPER
Sketchbook paper

PENCILS
2B and 4B pencils

OTHER
Pencil sharpener
Sandpaper block
Value scale

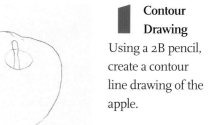

1 Contour Drawing
Using a 2B pencil, create a contour line drawing of the apple.

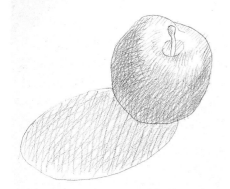

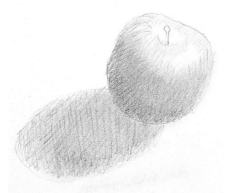

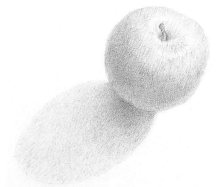

2 Hatch and Crosshatch
Using a sharp 4B pencil, hatch and crosshatch through the shade and shadow areas. Create all the shadows you see. Systematic hatching eliminates the open spaces and darkens the value. Use the value scale to compare the value in your drawing with the real objects. Squint to see the values more accurately. Add more hatching as needed.

3 Now Comes the Rub
Rub the hatched area carefully with your fingers. As the crosshatched lines disappear, a solid tonal mass is created. The form flattens, the grain of the paper disappears and the tooth of the drawing surface is slightly burnished.

4 Refine the Drawing
Refine the drawing by adding hatched lines without any further rubbing. Don't increase the pressure on the pencil. Keep the pencils sharp during the entire drawing process; a sharp point penetrates the paper grain. Darken the value and increase the density. Use the final hatching to combine the applied lines with the rubbed areas to show the mass, volume and direction of the light.

QUICK TIP

Sharpen your pencil often to achieve the finest line and greatest density.

Eraser Characteristics

Erasers are useful tools to remove a drawn line or tone but are also good for smudging, partially lifting values and creating marks. Erasers come in many styles, each one with different characteristics.

Make sure the surface of the eraser is clean before you use it. Dirty erasers will smudge your paper. Erasing always changes the look of the drawing; therefore, you must be open to accepting or adjusting each new stage of your drawing.

Types of Erasers

Soft erasers, such as Pink Pearl, Factis white erasers and kneaded erasers work best because they are designed to be used with pencil. You can use other types of erasers as well, but the soft ones are easier on paper than the hard ones.

A hard eraser may bruise or tear your paper surface, which will make the paper difficult to draw on. Damaged areas not only look different and darker than surrounding areas, but can also cause problems with any line or tone applied to that erased portion of your paper. Some erasers, if used incorrectly, may even ruin a drawing. A fiberglass eraser, for example, could ruin the surface and erase right through the paper. If you must use a hard eraser, do so with a light, delicate pressure.

The *kneaded eraser* is a pliable type of soft eraser that can be used for removing marks and as a drawing tool. Similar to soft putty, this eraser may be pulled and molded into all kinds of shapes, points and configurations for specific erasing purposes and to erase in hard-to-reach spots. Sometimes repeated erasures to the same area may be required to achieve the desired results. And you must re-knead the eraser to a clean point for each use. Kneaded erasers work with pencil as well as with other mediums, especially charcoal and Conté crayon.

You can use a kneaded eraser as a drawing tool to produce lighter lines and marks. You can also remove marks from the paper without rubbing by simply pressing the eraser to the paper and lifting.

A kneaded eraser can be pulled and kneaded into all kinds of useful shapes.

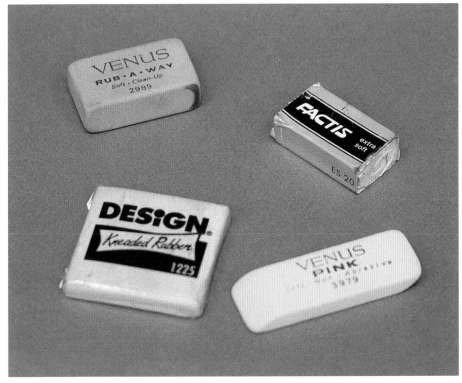

There are several types of soft erasers used for pencil drawing.

WORDS TO KNOW

KNEADED ERASER A pliable soft eraser that is very safe for drawing surfaces.

29

Let's Erase!

Make sure you do all these erasing exercises to complete your introduction to drawing with pencil. This is like nothing we've done so far.

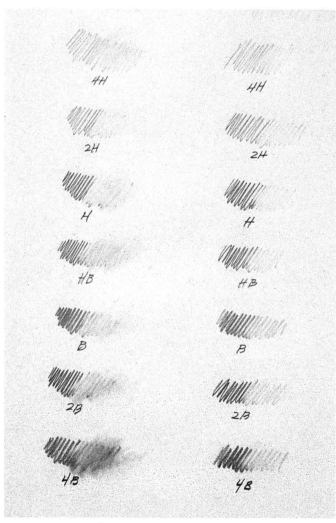

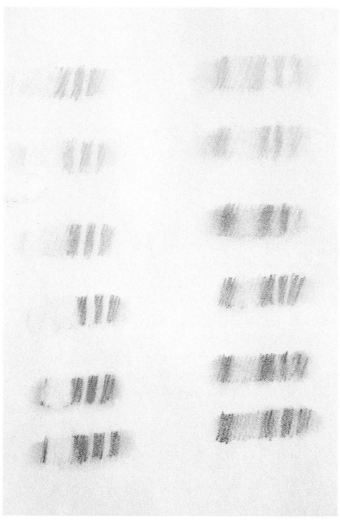

Simple Exercises

Create two sets (left and right) of hatched line masses starting with a 4H pencil and continuing through a 4B. Now attempt to completely erase the right half of the first set with a white soft eraser. Erase half the second set with a kneaded eraser and compare the results.

The white eraser did a better job than the kneaded one, didn't it? The difference is subtle, but if you look closely enough, you'll see it.

QUICK TIP

Continue practicing this exercise in your sketchbook, creating new sets of massed areas, but this time use a hard eraser to see how it compares to the other erasers. Subtle changes are important strengths in a drawing.

Changing the Format

Repeat the same exercise by producing two more sets (left and right) of hatched lines, but this time, before you start erasing, *rub* the hatched areas to create a solid flat tone.

Beginning with the first 4H unit in the left column, use the white eraser to erase back to the white of the paper. Then, try to create some clean "white" lines in the right half of the same unit. Do the same thing to the other pencil units in the left column. Notice how cleanly the soft eraser works.

Follow the same procedure with the kneaded eraser on the right column of rubbed marks. Compare the differences and evaluate these results with the preceding exercise. The white soft eraser did a better job of cleaning back to the white of the paper than the kneaded eraser in this example as well. The kneaded eraser is useful for removing a small amount of value, but not for completely erasing it.

Moving On

Congratulations! You've completed the chapter on pencil. You've learned about the technical aspects of pencils, the tools associated with pencil drawing, how to make different marks (lines) for different purposes, how to create and change a value mass in subtle increments, and you've gained a few insights into the characteristics of paper. With this foundation, you'll find it easier to add to your skills in the following chapters.

You've also started to learn about the fundamentals of light, volume and depth. A thorough understanding and application of these basics will be easier to grasp after learning about each medium's technical qualities and its compatible drawing surfaces and tools.

It's important to complete all the exercises to gain the most from this book. The more you draw, discover and experience, the more you'll learn and the better artist you'll become.

An Important Note on Value

It's extremely important to learn how to see value. Using a value scale for comparison readings helps hone this skill. When you can see and match the values in your drawing with those of your subject, you've accomplished a major step in your drawing education.

When comparing values, squint your eyes so that all other characteristics (e.g. line, texture and color) are minimized and value remains as the only characteristic that you see. Start by squinting when looking at the subject matter, holding the squint and compare the values to your drawing. Adjust the drawing until the values match.

If you are able to grasp one value exactly, you can then compare every other value in your drawing to that one. If you err on the light side with your first value, every succeeding value in the drawing will be too light.

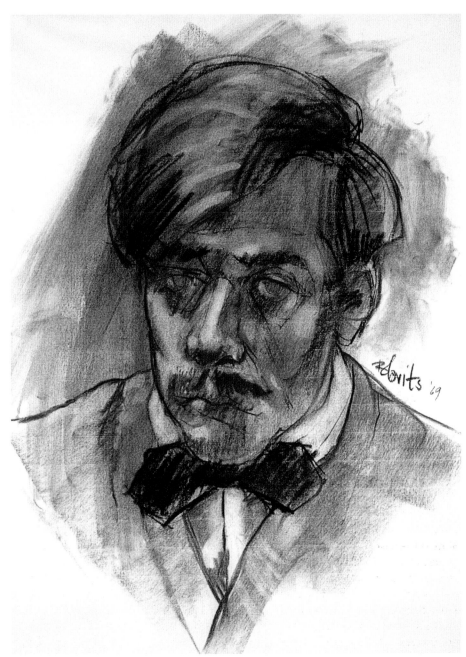

A Good Foundation
The foundation ground for this drawing was created using an old charcoal-laden chamois with added vine charcoal marks and values. Lighter values were created using the kneaded eraser and my fingers. You'll learn how to create foundation grounds and more value variations in chapter two.

DENNIS
Vine charcoal on Strathmore charcoal paper
24" × 18" (61cm × 46cm)
Collection of the artist

Charcoal

Charcoal is an exciting medium because you can manipulate it at will and create a wide range of values without worrying about color.

Traditional charcoals (vine charcoals) were made from sticks and vines carbonized by heating the wood in airless, heated chambers. Contemporary alternatives are compressed charcoal sticks and pencils, which produce a deeper value of black than traditional vine charcoal. Both types are available for today's artist.

The exercises in this chapter are designed to help you become familiar with the charcoal medium and to discover how charcoal works on different drawing surfaces.

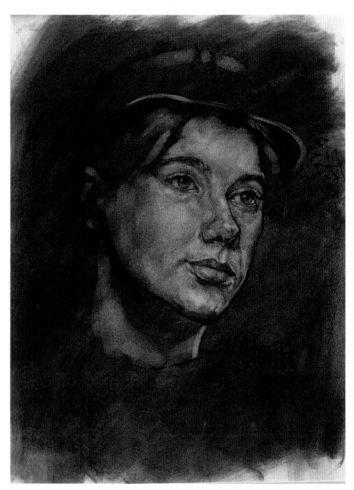

A Quick Sketch

This is one of the student actors at the college where I taught for twenty-six years. I asked the lead actors in the drama department to sit for quick sketches, encouraging each one to portray his or her favorite character while posing. The drawings were exhibited in the theater's foyer during the performance. It was great fun to try to capture the fantasy of the moment.

THE ACTRESS
Charcoal
24" x 18" (61cm x 46cm)
Collection of the artist

SHOPPING LIST

PAPER
Strathmore 500 series charcoal pad, 18" x 24" (46cm x 61cm), white or a comparable charcoal pad
Strathmore drawing pad 400 series, 14" x 17" (36cm x 43cm), white or a comparable drawing pad
Strathmore layout bond paper, 14" x 17" (36cm x 43cm), 16 lb. (35gsm), white or a comparable smooth, light-weight, all-purpose bond paper

CHARCOAL
Charcoal pencils—one each extra soft (6B), soft (4B), medium (2B), hard (HB), and white • Compressed charcoal—2 sticks, extra soft; 1 stick soft; 1 stick medium • Vine charcoal—4 sticks soft; 2 sticks medium; 2 sticks hard

OTHER
Kneaded eraser • Chamois • Spray fixative for charcoal • large blending stump • small blending stump

Vine and Compressed Charcoal

There are huge differences in quality and function among charcoals. Unless you are directed to the best-performing materials, you won't receive the maximum benefits from the exercises. This is particularly true for compressed charcoal. I prefer compressed charcoal from Grumbacher, but ask your favorite art supplier to recommend a professional-grade charcoal.

Compressed Charcoal

Compressed charcoal comes in stick or pencil form. Pencils are available in a wide variety and you'll have to experiment with them to discover their various qualities. Purchase ones you can sharpen in a pencil sharpener. Charcoal pencils come in a variety of hardnesses, just like graphite. A good selection to have in your art box is 6B Extra Soft, 4B, 2B, and HB (hard) or Medium Hard. There is also a white charcoal pencil that can be very useful, especially when working on toned or colored papers.

Vine Charcoal

Vine charcoal is also manufactured in different densities, sizes and thicknesses. It too comes in extra hard, medium, soft and extra soft.

Thinner sticks are useful for creating finer lines, and the thicker ones are good for wide strokes or large masses of value. Be careful with the thinner ones though, because they easily snap when even a little pressure is applied.

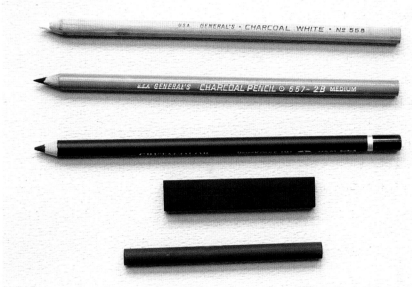

Compressed Charcoal Pencils and Sticks
Compressed charcoal sticks are useful for laying down wide strokes with ease. Pencils are for more delicate work. There is even a white charcoal, which gives you a little more control in producing the lightest values in your drawing. Sometimes the charcoal stains the paper, making it impossible to erase back to the white of the paper. That's where the white charcoal fits in as one of your drawing tools. It easily covers any darker value and allows you to create the whitest value in your drawing.

WORDS TO KNOW

VINE CHARCOAL Charcoal made from carbonized wood.

COMPRESSED CHARCOAL Charcoal sticks or pencils made denser and darker than vine charcoal.

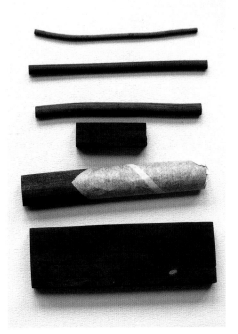

Choose From a Variety of Sizes
Vine charcoal comes in all shapes and sizes. I recommend the softer sticks rather than the harder sticks because you can create a greater variety of values. A stick ¼-inch (6mm) thick is the best size to choose. The thinner variety, about ⅛-inch (3mm) thick, has a tendency to snap too easily when pressure is applied unless you grip it near its drawing end.

QUICK TIP

When using thin charcoal, grip it near the end to prevent it from snapping.

Paper and Other Supplies

Charcoal drawing requires a paper texture with a tooth. In general, papers range from smooth to rough, but some have a more textured side produced by the use of drying screens in the manufacturing process. You don't want a paper that has an offensive texture or disturbing pattern, which can be distracting to the eye.

When selecting paper, the characteristics of the paper should match the drawing medium. This union can determine the success or failure of your drawing.

All papers are not of the same quality. Seek out the best you can afford; it's worth your time and money. I use Strathmore 500 series charcoal paper in the large pad, 18" × 24" (46cm × 61cm), but any quality charcoal paper will suffice.

You should also purchase some high-quality bond paper with a vellum surface and a pad of medium-textured paper. Try some Strathmore layout bond paper, 14" x 17" (36cm x 43cm), 16-lb. (35gsm), with a vellum surface, and a Strathmore drawing pad, 400 series, medium texture, in the same size. If you are unable to find these papers, any similar quality paper will suffice. We'll use all of these types of papers throughout this book.

Experiment with all drawing techniques on various papers before you attempt any serious drawings. Exploring how and why materials work the way they do will provide you with valuable insights about the benefits and the limitations of your drawing tools and surfaces.

Other Useful Tools

In addition to the right paper and charcoal, it is a good idea to have a chamois, kneaded eraser and possibly a blending stump or two. Keep this set of tools separate from your materials used for drawing in other mediums; use them only for charcoal, as they may "dirty" the other drawing media if used together.

Types of Paper
You can buy charcoal paper in a variety of colors. The colored sheets are especially handy if you're adding white to the foundation color as in many Old Master drawings.

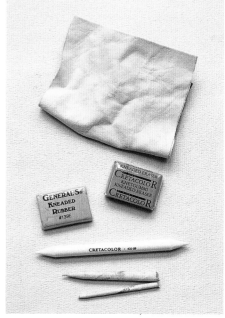

Tools of the Trade
I always have a chamois, kneaded eraser, stump and a tortillion on hand. The chamois acts like an eraser (it blends and neutralizes everything). The kneaded eraser is not only a removal tool but can also be a drawing instrument. Stumps and tortillions are useful for blending values on the surface.

Explore Charcoal

This first exercise is a raw approach to the medium of charcoal. Jump right in and try this simple exercise using the same techniques you learned in chapter one. You will find that charcoal is very different from pencil.

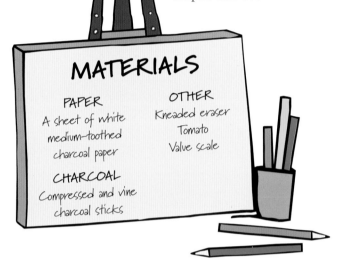

MATERIALS

PAPER
A sheet of white medium-toothed charcoal paper

CHARCOAL
Compressed and vine charcoal sticks

OTHER
Kneaded eraser
Tomato
Value scale

QUICK TiP

- Clean the pointed end of the stump with a kneaded eraser to remove excess charcoal.
- Vine charcoal can be sharpened with sandpaper or a sandpaper block to produce a sharp, chisel edge for a thinner line.

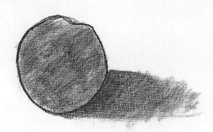

1 Draw a Simple Object

Use vine charcoal to draw the contour line that describes the border of the tomato. Vine is the best choice for the initial drawing marks, because compressed charcoal doesn't erase as easily. Add a layer of vine charcoal to begin the tonal base. Try to match the values using the value scale.

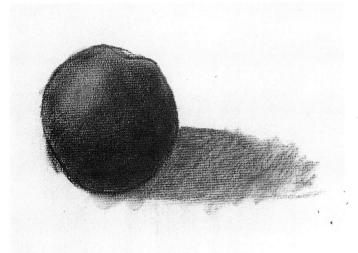

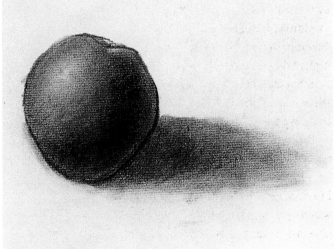

2 Add Hatched Layers

Add a hatched layer of compressed charcoal to the darker areas first, then add another hatched layer of the vine charcoal on top. Rub the two together to create a darker foundation and adjust accordingly.

3 Lift and Lighten

Lighten the left side by lifting some charcoal with your fingers first, then using a kneaded eraser. Finally, lightly remove a minimal amount of charcoal from the shadow side with your fingers to create the subtle reflected light area.

Create Backgrounds For Your Drawings

In this exercise you will produce different foundation backgrounds (often simply called *grounds*). You will be using both vine and compressed charcoal to create a ground on which you can build a drawing.

Remember, drawing knowledge is cumulative. What you learn in one medium is often transferred and carried on to the next medium.

MATERIALS

PAPER
A sheet of white medium textured charcoal paper

CHARCOAL
Compressed charcoal sticks—soft

Vine charcoal sticks—extra soft

MISCELLANEOUS
Chamois

WORDS TO KNOW

TONAL Refers to values from white to black that convey volume, lightness and darkness.

1 Vine Charcoal Ground

Cover a section of paper using the side of a soft vine charcoal stick. Using medium pressure and the flat of your hand or fingers, rub the vine charcoal into the paper to produce a flat tonal mass. On the right half, apply more vine charcoal and rub it in to create as dark and flat a value as you can. Notice that the value doesn't really get very dark because of the nature of the vine charcoal. Vine charcoal creates a translucent surface; the white of the paper still shows through.

Compare the right and left sides. Notice the difference in the opaque density produced by adding layers of vine charcoal.

Save this sample; we'll use it again on page 38.

2 Compressed Charcoal Ground

Cover a new section of paper using a stick of extra-soft compressed charcoal. Rub it in to produce a solid, flat value. Don't worry if you're not able to create a flat value instantly. On the right half, apply additional layers of compressed charcoal, rubbing thoroughly to make the area as dark and flat a value as you can.

Notice how much darker the right side is compared to the left. Additional layers increase the density and further cover the white paper. Because of its unique properties, compressed charcoal layers build up a darker tone and become darker much faster than the vine charcoal. Also notice that the texture of the paper isn't as obvious on the right side.

Save this sample; we'll use it again on page 38.

3 Combined Ground: Compressed Plus Vine Charcoals

Apply extra-soft compressed charcoal over an area of paper, then rub lightly over the whole surface with the chamois to eliminate the grain and create a solid tone. If the chamois removes too much charcoal, apply a second layer and repeat the procedure. You should have a flat, grainless tone. Eventually the chamois will become completely saturated with charcoal and creating a flat tone will be much easier.

Now, apply a layer of vine charcoal on top of the compressed charcoal. Take the flat of your hand or fingers and lightly smooth the vine charcoal over the compressed charcoal to produce a flat tone.

Look at the tone you've created. It's different from the tones you created in steps 1 and 2. This ground is a solid, dense base composed of one layer sitting on top of the other.

Grounds

There are three things to remember about grounds created with charcoal: (1) Charcoal sits on the surface in various thicknesses or densities; (2) The charcoal layers act as opaque screens, shutting off the white of the paper; (3) Thinning down the charcoal layers makes the surface look more translucent.

A kneaded eraser was used here. As you can see, the charcoal may or may not stain the paper, depending on which type you use. Vine (because it doesn't hold onto the paper as well) will clean off more completely when erased and doesn't stain the paper as much. Note how the erased compressed charcoal stains the paper.

QUICK TIP

✎ The key to success with step 3 is using the chamois to blend the first layer of compressed charcoal. It fills the grain and produces a uniform foundation. The blended, compressed base with the vine charcoal applied on top, produces a dense layer of charcoal that is easily lifted and erased.

✎ Apply the vine charcoal so that it sits on **top** of the compressed charcoal, rather than becoming mixed into it.

Grain Makes a Difference

The grain of the paper is often accentuated by the application of the drawing medium. Here you can see the "ribbing" in the charcoal paper created during the manufacturing process. The grain holds the charcoal on the surface, but sometimes it inhibits rather than helps the drawing process. In other words, if the grain is too dominant, it can overwhelm or eliminate subtle value changes and delicate lines.

Creating Values by Lifting and Erasing

In this exercise you will learn different means of lifting and erasing charcoal as well as the values that you can achieve with different types of charcoal. You will also find out which ground lifts most easily.

Removing Charcoal to Create Values

Grab your finished exercise from step 1, page 36 (vine charcoal ground), and let's learn about lifting and erasing vine charcoal.

a) Touch into the left half of the vine charcoal tone with your index finger, using light pressure. Clean your fingertip and touch into the right half with the same pressure.

b) Clean your fingertip again and create a new mark next to the previous one in both halves of the vine charcoal; use the same pressure, but slightly drag your finger. The mark on the left is easily seen, while the one on the right isn't. The touch-and-lift method removes the least amount of charcoal; however, dragging lifts a little more charcoal than simply touching, as you can see from the examples. There is a subtle difference between touching and dragging. You can create lighter spots in the charcoal surface with your fingers by using different pressures and motions.

c) Mold the kneaded eraser into a stick with a round end and touch a new spot adjacent to the other marks on both halves, using the same pressure. Don't scrub; just touch the surface so you can compare it to the other marks. Make note of how much charcoal is removed from each side.

d) Underneath the first eraser mark, create another mark with a clean spot of the eraser by touching and dragging, just as you did previously with your finger (step b). This time you will be able to remove more charcoal than before from both halves. There is still some charcoal on the surface; you're not back to the white of the paper yet.

e) Now create a third eraser mark, but this time try to remove all of the charcoal by attempting to erase back to the white of the paper.

As you have seen and experienced, the five different marks represent five different values made with various subtractive methods.

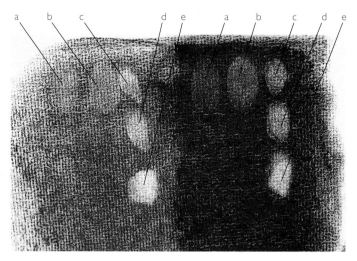

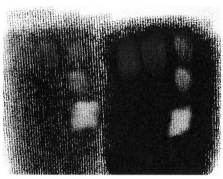

Repeat the same exercise with the compressed charcoal grounds (step 2, page 36). You will find it more difficult to show value differences in the lifting. Why? Because the compressed charcoal really holds on to the paper, whereas vine charcoal doesn't. This characteristic makes the compressed ground less flexible than the vine as far as lifting and erasing goes.

Which Ground Lifts More Easily?

Create a combined ground as you did on page 37 by first applying a compressed charcoal layer. Repeat the lifting and erasing process as you just did for the previous two grounds. Evaluate and compare this combination ground with the other two grounds. The combination ground lifts from the paper more easily. There is no competing grain to interfere with the image development because the chamois deposited the charcoal evenly over the entire surface.

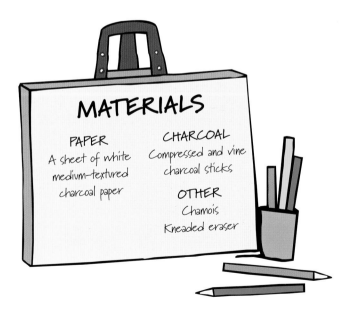

MATERIALS

PAPER
A sheet of white medium-textured charcoal paper

CHARCOAL
Compressed and vine charcoal sticks

OTHER
Chamois
Kneaded eraser

Value Scales with Charcoal

As an artist you must be able to identify the values you see and to transfer those values to your drawing. In chapter one you saw a value scale drawn in pencil. Now, using different charcoals, you are going to draw your own value scales. You'll need a few sheets of your white medium-textured charcoal paper, your vine charcoal sticks (soft, medium and hard) and your compressed charcoal sticks (soft, medium and hard).

Graded-Value Scale

With a graded or transitional value scale, the values are not separate blocks; they transition into one another just as they would in a drawing. You will use graded values throughout this book.

Creating these value scales will help you know which charcoals produce the lightest and darkest values so that you can easily reproduce them in your drawings. The ability to control the sequencing of value changes from light to dark, or vice versa, is useful to indicate volume. You can make objects look round by using this procedure.

Follow the captions to create two value scales using vine charcoal first, then use compressed charcoal to create the next two. When you're finished, be sure to compare the results , and decide which method works best.

Graded-Value Scale Using Only Soft Vine Charcoal

Divide a piece of paper in half, and using only soft vine charcoal, create a graded-value scale from the lightest to the darkest value. Isolate the white area first as shown, then apply light hatching below the white area and gradually increase pressure as you move down the value scale to the darkest value. Don't be surprised if your darkest value isn't black.

Graded-Value Scale Using Varied Vine Charcoals

Create another graded-value scale next to the previous one by first isolating the white area as shown. Using hard vine charcoal, apply the lightest tonal value with light pressure and gradually increase the pressure to create the darker values in the light section. Use the medium vine charcoal for the middle values and the soft for the darkest values.

QUICK TIP

- Reknead the eraser each time you use it or you'll transfer some of the charcoal you just erased back to the surface!
- Surround and isolate the first value area (value 9), the white of the paper, with a darker tone.
- Vary your pressure for each section, starting with light at the top and increasing the pressure gradually until you move to the section with the next softest charcoal. Vary the pressure again with each succeeding type of charcoal.

Understanding Graded Value

If your value scales are done properly, you should see nine different values in progression from white to black on each scale. Keep the following points in mind as you continue to work with value.

- The ability to control the sequencing of value changes from light to dark, or vice versa, is useful to indicate volume. You can make objects look round using this procedure.
- When you compare the four value scales (two vine and two compressed), they will look different. The lights are easier to control with harder charcoal. Medium hardness works better for the middle values and soft for the darker values. Creating a darker dark is easier with the soft or extra-soft compressed charcoal.
- You are more dependent on hatching and crosshatching to darken values with vine charcoal.

Creating value transitions is important, but so is the ability to create a flat value (one consistent value throughout a specific area).

Creating a Flat-Value Scale

This skill is useful when rendering the flat side of a box, a flat wall or the side of a building. Create another set of value scales, the first with vine and the second with compressed charcoal. This time, however, separate them into nine flat-value units.

With this exercise, you will learn how to create flat values, how to create and judge the position of values on a value scale, and how to use the right tools and techniques to create each value. You'll also learn more about the characteristics of each charcoal type.

Graded-Value Scale Using Only Soft Compressed Charcoal
Divide another piece of paper in half and use soft compressed charcoal to create the same graded-value scale that you made on the previous page. Again, this will go from white to black. Isolate the white value at the top as shown. Start with a light hatching and gradually increase the pressure as you create the changing values down to the black. Did you have a lot of control?

Graded-Value Scale Using Varied Compressed Charcoals
Create a second graded-value scale next to the first. Isolate a white value at the top, but this time start by using the hard charcoal at the light end, switch to the medium for the middle, and use soft for the rest of the way to dark. See if you can control the transitions.

Begin Your Flat-Value Scale Using Vine Charcoal

Using vine charcoal, draw the outlines of nine squares. Surround the white value (value 9) with a tonal area. Establish the darkest (black) flat value (value 1) at the bottom. You will have to judge the appropriate pressure to produce it. Use cross-hatching and multiple layers to create the other flat values. Make them as even as possible with no value variations within the squares. At each stage, think about whether you want to use your hard, medium or soft charcoal.

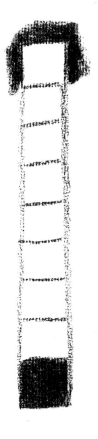

Fill in The Middle Values

Create the middle value (value 5) halfway between white and black. Once you have established value 9 (white), value 5 (middle value), and value 1 (black), create the intermediary values between these two (for example, value 3 between 1 and 5). Continue until all values are complete. Remember to consider at each stage whether you want to use your hard, medium or soft charcoal.

It's much easier to create a value scale this way, rather than working progressively from lighter to darker. Was it difficult to create the flat values with the vine charcoal sticks?

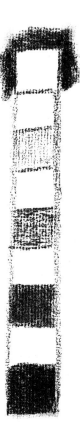

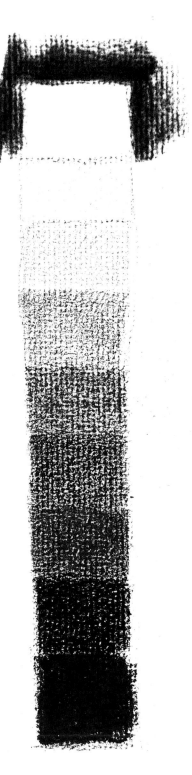

Try a Compressed Charcoal Flat-Value Scale

Following the same sequence, make a new flat-value scale using compressed charcoal sticks and pencils. When creating the light values with the hard compressed charcoal, use light, delicate pressure. Use the same light pressure with the medium stick for the middle values, but gradually increase pressure when using the soft stick for the darkest values.

Light Types and Sources Affect Value

When setting up a still life, it's important to consider the type of light, as well as the source from which it originates. Three common types of light that are considered throughout this book are concentrated, secondary and diffused.

Concentrated Light

Concentrated light is a strong light created by one nearby source, such as a lamp or window. All other light sources are blocked off. This makes the light and shadow sides of an object obvious, as well as allowing you to clearly see value gradations. Drawings created using concentrated light use almost the entire value scale (from white to black) for their value ranges.

Secondary Light

The primary function of a secondary light source is to help create a convincing feeling of volume in your drawing. In reality, the light rays from the dominant light source pass by the main subject and reflect off other surfaces back to it, slightly illuminating the shaded side of the form. Adding reflected light makes objects look rounder, thereby making the illusion of volume more convincing.

The secondary light should be less than half the power of the dominant light source if placed an equal distance from the subject. For example if the dominant light is 100 watts, the secondary should be 50 watts or less. If the two are of equal power, the secondary should be at least twice the distance away from the subject as the dominant light. When you see subtle lighting on the shadow side of your subject, your secondary light source is at the proper distance. The secondary light might also be a result of naturally occuring reflected light, without an additional lamp.

Diffused Light

Diffused light is a less dramatic, soft light; for example, light coming from an overcast, cloudy sky. Fluorescent light is another good example of diffused light. Compare concentrated light and diffused light. You see only a small range of values (about one-third of the value scale) in diffused light. You won't see the lightest lights or darkest darks.

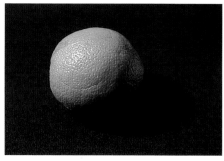

Concentrated Light From One Source
Here is an orange lit with one nearby concentrated light source. You can see how there is very little value change within the shadow area.

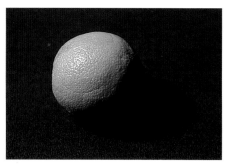

Concentrated Light
The concentrated light setup exhibits a dramatic change in value from light to dark with a definite, abrupt shadow edge (the transition border between light and dark areas on the round forms) and a definite cast shadow shape (flat value).

The values represent about two-thirds to three-quarters of the value scale.

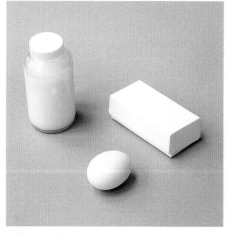

Secondary–Reflected Light
Light from the main source bounces off the box and back to the orange. You can see the effect of the reflected light and how it makes the object appear rounder. Using a secondary light source also produces a reflected light, which creates convincing volume.

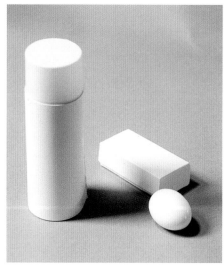

Diffused Light
Diffused light has a soft, continual transition of values without any abrupt shadow edge in its form or cast shadow. The values represented are about one-third of the value scale.

How to Create the Illusion of Volume

Volume makes objects look round and realistic. You can create the illusion of volume by re-creating the areas of light and shadow on your subject. These areas include: the *highlight*, the lightest value on the form; *halftones*, the transition value range between the lightest value (highlight); the *core shadow*, or the darkest value on the form; the *cast shad-* ow, or the darkest value in your drawing, which always is opposite the light source; and *reflected light*, a slightly lighter value than the core shadow, found on the opposite side of the form away from the main light source.

Notice the different effects that diffused and concentrated light create on a round object.

WORDS TO KNOW

HALFTONES *The values in a drawing that are midway between the lightest and darkest values.*

REFLECTED LIGHT *The relatively weak light that bounces off a nearby surface onto the shadowed side of a form.*

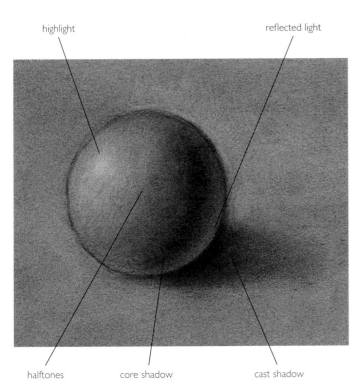

highlight reflected light

halftones core shadow cast shadow

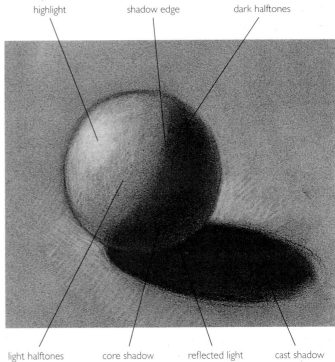

highlight shadow edge dark halftones

light halftones core shadow reflected light cast shadow

Diffused Light
Here's a breakdown of a diffused-light situation. The soft light is coming from a great distance, rather than from close by. The value changes from the highlight to the deepest value (core shadow) are gradual. All the values are going through a gradual transition, even the cast shadow.

Concentrated Light
These are the elements of concentrated light. The value changes in both the light side and the shadow side are very subtle, but the transition from light to dark at the shadow edge is very abrupt. The cast shadow is a very distinct shape with very little value change.

Drawing a Cylinder

A drawing's appearance is affected by different drawing surfaces. In the previous exercises, you used medium-textured charcoal paper, a surface that was specially designed to hold charcoal. Now you'll be using a smoother vellum surface called layout bond paper. It's important to understand how different charcoals react with each paper surface so that you can choose the best combination for each of your drawings.

In the first chapter (page 13) we discussed three processes that are used with all drawing mediums: additive, subtractive, and additive-subtractive.

In the subtractive method, you first create a medium-value base and then remove, in subtle or dramatic increments, various amounts or levels of the medium using fingertips, erasers or a chamois.

In the additive process, the charcoal medium is applied to the paper in successive layers to create the drawing. Everything you'll produce is created through hatching and crosshatching, using different pressures.

Your experience creating value scales, coupled with the drawing procedures you learned in chapter one, will help you to create a believable curved shape.

MATERIALS

PAPER
A sheet of white layout bond paper

and hard
White charcoal pencil

CHARCOAL
Vine charcoal sticks—soft, medium

OTHER
Chamois
Cylindrical object
Eraser
Stump

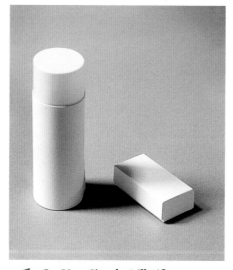

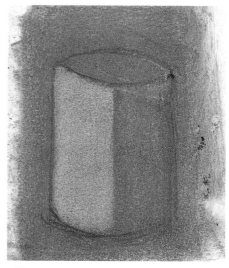

1 Set Up a Simple Still Life
Set up a very simple still life that includes a cylinder. Use only one nearby concentrated light source (a lamp or window) to light the setup. Block off all other light sources; this will make the light and shadows obvious, as well as allow you to clearly see the value gradation on the cylinder. Once your setup is complete, draw the shape of the cylinder.

2 Create an Even Foundation
Create an even value foundation with the vine charcoal, then begin removing (subtracting) the foundation. Experiment, using any method that you have learned about, such as finger, eraser or chamois.

Concentrate on the cylindrical form. When you start to create a rounded form, simplify the process by first removing a small amount of the medium to create a lighter value on the light side of the object.

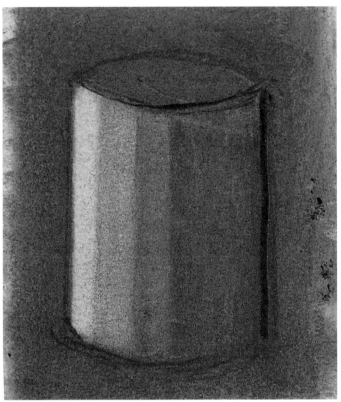

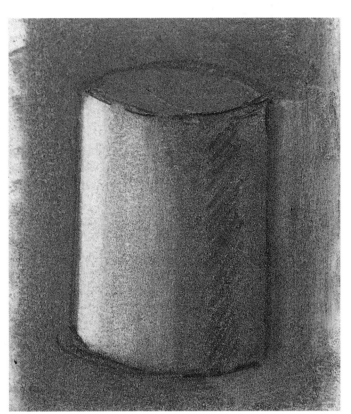

3 **Lift to Create More Light**
Create two more flat-value steps by lifting more charcoal off the areas facing the light, leaving the third transition created in the previous step. Use the white charcoal pencil (additive process) to lighten the transition nearest the light even more.

4 **Soften the Transition and Hatch the Core Shadow**
Use your fingers and a stump to soften the edges of the transitions so the object's surface will appear as if it's curving. Hatch (additive process) a darker area in the shadow portion of the cylinder to act as the core shadow. The area to the right of this hatched area then will begin to have the appearance of reflected light.

QUICK TiP

✐ You can use a chamois to obliterate the drawings that you don't want to keep. This in turn will create a neutral-toned surface ready for future drawings; a resurfaced paper is just as good to practice on as any. Practice drawings aren't precious, but what you learn from practicing is!

✐ More than one dominant light source will create visual confusion and may eliminate helpful form–building shadows.

Draw a Simple Still Life

Now that you've had some practice using layout bond paper and have learned how to create a rounded form, let's move on and complete a simple still-life drawing, this time using compressed charcoal on layout bond.

Compressed charcoal works better than vine on this paper because it doesn't depend on a rough texture for adhesion like vine does.

Restricting yourself to one type of charcoal forces you to really explore the unique properties of that specific drawing medium in combination with various papers.

MATERIALS

PAPER
A sheet of white layout bond paper

CHARCOAL
Compressed charcoal sticks and pencils—soft, medium and hard

White charcoal pencil

OTHER
Chamois • Eraser
Still-life objects
Stump • Tortillion

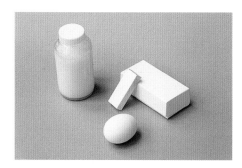

1 Set up the Still Life
Set up a still life with four simple forms, using a concentrated light source (as you did for the last exercise).

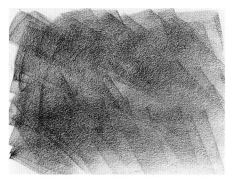

QUICK TIP

☞ A textured area has a tendency to dominate and demand visual attention, becoming a competitive element rather than a subordinate one. A smooth area allows the viewer to concentrate on the still-life forms without visual interference from surrounding textures.

☞ Visual activity helps to create a focal point. You want your subject to be the focal point of your drawing. So visual elements such as line, texture and value differences should be less defined as you move away from the still life—the center of interest.

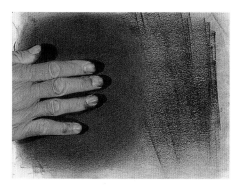

2 Create a Foundation
Using the layout bond paper, create a foundation using compressed charcoal. Use the chamois to blend the initial charcoal application. Apply the next layer of charcoal and smooth it with your fingers.

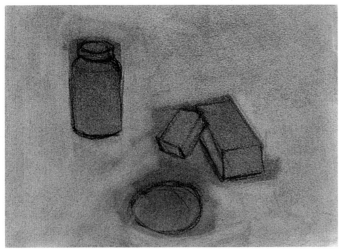

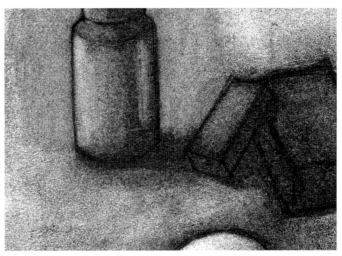

3 Create the Drawing

Draw the still life using both compressed charcoal sticks and pencils, along with the stumps and erasing tools. Start removing tone from the large nondescript areas with the chamois.

4 Subtract and Smooth

Develop the drawing by subtracting with your fingers, eraser and stump. Notice how the stump-smoothed area next to the bottle is more neutral than the active grain at the bottom.

The texture adjoining an object may be too active or too pronounced (see Quick Tip on page 46). You can quiet it down by rubbing (smoothing) with the tortillion or the stump. This makes the area passive and puts the visual emphasis back on the object, where it belongs.

5 Lighten White Areas, Correct and Unify the Drawing

When you can't get the white areas any whiter (because the charcoal has stained the paper), use the white charcoal pencil to eliminate or suppress the stained area and lighten the object further.

Unify the background value so that it is less distracting. Check your drawing and adjust as necessary. Corrections can be made anytime in the drawing—if it's not right, fix it!

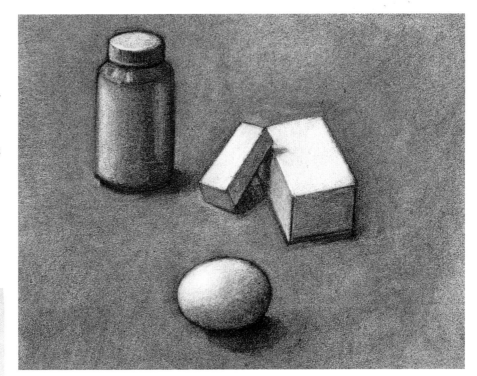

QUICK TIP

Keep a low-power vacuum on hand to remove excess charcoal dust from your drawing surfaces. You'll also find a vacuum useful when you begin working with pastels in chapter four. Keeping your drawing surface clean is important!

Drawing Drapery Folds

Let's draw a more complicated still life; this time add some drapery. Use one dominant light source as before, but now use a full sheet of paper to make a larger drawing. To change values, use the hatching technique with the hard, medium and soft charcoal pencils. You'll have more control with pencils than with sticks.

Create a combined foundation ground as you did on page 37 (apply soft compressed first, blend with a chamois second, apply soft vine charcoal third, then smooth with your hand). Since this paper has a medium texture, make sure you blend with the chamois so the foundation is a flat, grainless tone. Eliminate as much of the texture as possible.

Test the lifting procedure in the top-left corner. If the foundation doesn't lift easily and cleanly, apply a second foundation coat using the same process. When you touch the surface and a clear, lighter mark is visible, your liftable ground is established and you're ready to draw.

See and think about the value transitions that occur in the drapery folds; these will be drawn similarly to the cylinders. They're both round and have a similar series of value transitions.

MATERIALS

PAPER
A sheet of white layout bond paper

CHARCOAL
Soft, medium and hard charcoal pencils

Soft vine and compressed charcoal

OTHER
Chamois
Kneaded eraser
Still-life objects

Still Life With Drapery

This still life was set up using one dominant light source.

Compare the Roll to a Fold

Here's a closeup so you can compare the similarity between the cylinder and the fold. Every shape can be related to a simple form, e.g., cylinder, cone, sphere, cube or pyramid; so always look for the simple forms within the complex ones to better understand how to draw them.

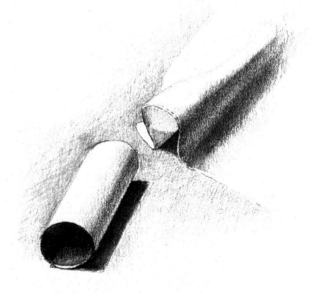

Drawing of Roll and Fold

Here's my drawing of the setup. You can see how I related the drapery to the simple cylinder form. I did the majority of this drawing by hatching and cross-hatching with charcoal pencils.

Using a Fixative

As I'm sure you've already figured out, charcoal is very messy. To preserve completed drawings (of any medium), you need to spray them with fixative. You must have adequate ventilation while spraying. The best solution is to spray the drawings outside in the open air, not indoors.

Carefully follow this spraying procedure; many students ruin their drawings by spraying too close or overspraying. Determine the wind direction first with a test spray so you don't inhale the vapors by spraying into the wind. Position the drawing vertically and hold the can about 8 to 10 inches (20cm to 25cm) away. Spray off to the side of the drawing first and then spray across the drawing in a horizontal fashion, moving progressively from top to bottom. Keep the can moving; don't stop on the drawing surface, and don't allow the fixative to run.

Fixative dries rapidly (within 15 seconds). Touch an unimportant area of the drawing lightly with your finger to see if any charcoal comes off. If so, spray it again. Two thin coats are always better than one thick one.

When you are finished, turn the can upside down, point it away from the drawing, and with one quick spray, clear the nozzle of fixative. Only compressed air comes out, and this cleaning procedure allows the nozzle to perform perfectly the next time you use it.

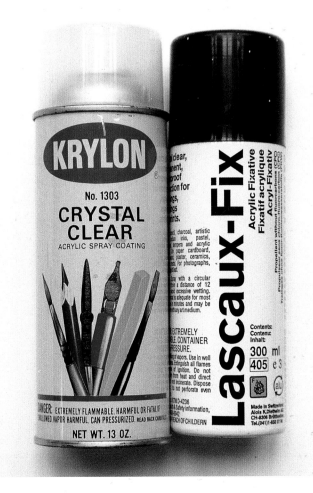

WORDS TO KNOW

STILL LIFE Inanimate objects used as subject matter, not to be confused with a landscape or figure.

TRANSITION The gradual or sequential change from one state to another.

FIXATIVE A spray that provides a transparent protective coating over a drawing to shield it from smearing or damage.

Conté Crayon

We'll use Conté crayon for our transition into color. Conté is a mixture of compressed pigments, clay and a slightly greasy binder. Conté crayons come in a hard stick form and are smooth and rich in pigment.

Conté crayons blend more easily and softly than wax or grease crayons. They range from soft to hard, but the harder varieties of Conté crayon often display a glossy look if overworked, especially the blacks.

In the previous chapters on pencil and charcoal, you were concentrating on one characteristic: value. Drawing with color is, however, a little more involved. Besides value (lightness and darkness), color contains three additional

characteristics: *hue* (color identity), *intensity* (brightness and dullness) and *temperature* (warmth and coolness). While value is still the most influential element of the four, the other elements are also important factors.

The Conté colors you will need for this chapter are all contained in the Conté A Paris Studio Sketch Set (see page 51) but if you prefer to purchase them separately, every color you need is included on the shopping list.

SHOPPING LIST

PAPER
Two sheets of Canson Mi-Teintes no. 431, Steel Gray
Drawing pad • Charcoal paper

DRAWING MATERIALS
Conté A Paris Studio Sketch Set, or comparable materials
that include:
Kneaded eraser • Stump • Tortillion
Conté sketching pencils—black, white and Sanguine (red)

Conté crayons
2B Black • HB Black • 2B white • HB white
Bistre Brown • Gray

Reds
Sanguine Natural • Sanguine XVIII Century
Sanguine Watteau • Sanguine Medicis

OTHER
Two chamois (one for the gray areas, one for the red areas)
Two white, short candles

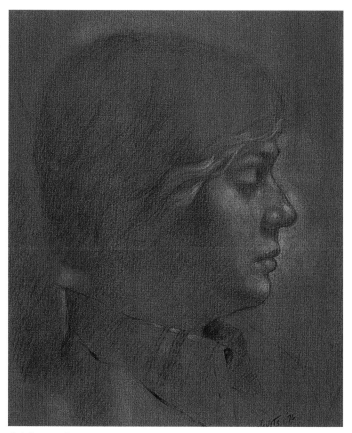

QUIET TIME
Conté crayon on Strathmore drawing paper
24" x 18" (61cm x 46cm)
Private collection

Getting Started

A quality set of Conté crayons such as the Conté Studio Sketch set contains all the colors and items used in this chapter. Red will be the main and most intense color we will use, while brown, white, gray and black will be used to alter the red. When added to red, each one reduces its intensity or saturation (brightness), changes its value and alters the hue slightly.

Four reds with slight variations in value are ideal. The white and black crayons are available in three hardness degrees, including HB, B and 2B. Most of the other colors are equal to a B in hardness. You want a light shade of gray and a dark, earthy brown.

Sketch Sets
Sketch sets are designed to provide you with the best range of colors and hardness degrees from which to choose. They allow you to conveniently purchase a wide range of colors and values at one time.

WORDS TO KNOW

HUE The common name for a color, such as red or blue.

INTENSITY The degree of brightness or saturation of a color.

TEMPERATURE The relative warmth or coolness of a hue.

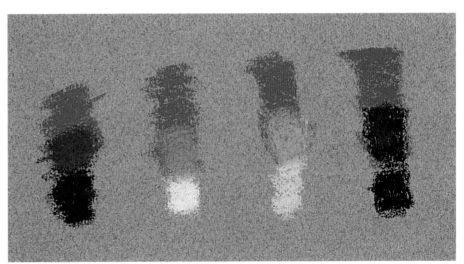

Adding brown, white, gray or black Conté will alter red values.

Paper and Other Supplies

Let's examine and experiment with the medium, tools and papers. In order to retain the purity and beauty of the Conté medium, use a separate set of tools for the Conté, not the same ones you've used for charcoal or pencil.

We'll use the same papers as for pencil and charcoal with the addition of Canson Mi-Teintes paper. Canson Mi-Teintes paper is available in at least fifty different colors and can be purchased in fine art supply stores. One of the unique characteristics of this paper is that it has a smooth side and a textured side. The smooth side is the side you want to use for drawing.

To distinguish the two sides, locate the side with an embossment along the edge that reads *Canson Mi-Teintes*, that is the textured side. If you are unable to find the embossment, apply a sidestroke of Conté near the edge of the paper to see if a pronounced texture appears. If you're still unsure, apply the sidestroke to the other side and compare textures.

Using the smooth side allows the artist to create and control the texture, not fight it from the outset as you would if you worked on the rough side.

Materials and Paper Used
Use the same papers and general tools that you've used in the previous chapters.

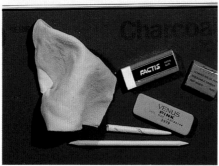

Canson Mi-Teintes Paper
Canson Mi-Teintes is an excellent paper to use for many purposes.

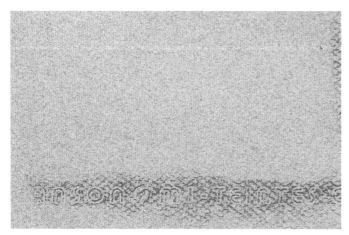

Look for the Embossing
You can recognize the textured side by the *Canson Mi-Teintes* embossment on the border. It becomes more visible with a sidestroke of Conté.

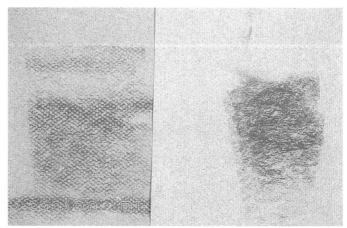

Textured Side and Soft Side
Notice the difference in the strokes of Conté on the textured side (left) and the soft side (right). The soft side is preferred for drawing with Conté.

Characteristics of Conté Crayon

Because Conté crayon has a slightly greasy binder, it adheres quickly to any paper surface, making the texture of the paper immediately evident in all the primary marks.

Conté's range of hardness and softness and its availability in stick or pencil form allows you to create a variety of marks. As with the mediums we've used previously, you can decide whether to use the additive technique and retain the pure, direct marks to create a drawing incorporating the grain of the paper, or use a combination of the additive and subtractive techniques instead.

You can make various types of marks with Conté depending on whether you use the end or the side of the stick; on how much pressure you apply; and on the texture of your paper. Strokes applied directly onto the paper reveal its grain.

Smearing
Conté can be smeared easily with a variety of tools, including the fingers and a chamois.

End and Side Applications
Conté may be applied using the tip of the crayon (left) or the side of the crayon (right).

Pressure Variations
By varying the pressure, you can make soft and subdued marks (left) or strong and definite ones (right).

Stick and Pencil Marks
You'll make a more general mark with the stick and a more precise line with the pencil.

Getting Into Color

All right, let's move on and explore a little color. The four characteristics of color are hue (the color), value (lightness or darkness), intensity (brightness or dullness) and temperature (warmth or coolness).

When we add white to a color, two changes occur: (1) the value lightens; and (2) the intensity weakens—it's not as red anymore, although it keeps its red hue. A less evident change also happens: the temperature becomes cooler, because white is a cool pigment.

When we add gray or black to our red color, the same three types of changes happen: the value darkens; the intensity of the red is reduced even more (white will change the intensity least, light gray a little more, and black the most); and the color is cooled down because black and gray are cool colors also.

Color changes can also alter the illusion of space or reality in the picture we are drawing. Pure, intense colors (ones without additional white, gray or black) come forward. Colors with white, gray or black added will recede. If you dull a background color by adding gray or black, a pure color in the foreground will appear to come forward even more.

Adding White
Adding white lightens the value of the red, decreases its intensity and cools the temperature.

Adding Gray or Black
Adding gray or black further reduces the intensity of the red, darkens the value and cools the temperature.

Dulling a Pure Color
Adding white or black to a pure color dulls the color and makes it recede when compared to a pure, bright color.

Darkening the Background
Darkening the value of the background surrounding a dulled color makes it recede even more.

Lighting Conditions

Previously we have used either sunlight or strong incandescent lighting in our demonstrations. Now we're going to explore a lower-intensity, incandescent source. We'll also explore the weakest illumination used by an artist: candlelight.

For the next few demonstrations, you'll need a desk lamp with a shade and a 25-watt bulb to create a lower illumination.

You'll also need a separate light source (such as a standing lamp) to light your drawing surface. Use any 75- or 100-watt bulb for this lamp. This lamp will also need a shade to prevent its light from reaching the still life. Since this light is shining directly on your work surface, you may need to wear a visor or baseball cap to block it from your eyes.

Candlelight

Candlelight is a very low-illumination light source. Color, intensity and description are dependent on the presence of light, so in order to see shape and value when using candlelight, you must place the objects only a few inches away from the candle. You'll also notice that because of the almost complete absence of ambient light, the shadow side exhibits little more than a flat value.

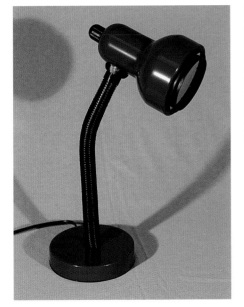

Desk Lamp
Use a desk lamp with a 25-watt bulb and a shade to illuminate the still life.

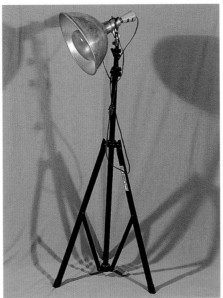

Standing Lamp
A lamp such as the one shown is great to illuminate your drawing surface. Be sure it has a shade so that it doesn't illuminate the still life you are drawing.

QUICK TIP

An excellent example of candlelight as the solitary light source is found in the work of Georges de La Tour (1593–1652). Go to the library and look up examples of La Tour's paintings in art history books. It's helpful to study how a master uses this type of light.

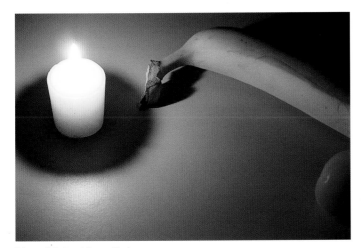

Have Light, Have Color
Notice that only the candlelit surfaces appear to have color. The absence or reduction of light creates the absence or reduction of visible color.

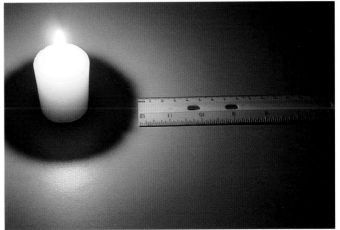

Candlelight Falls Off Quickly
Keep in mind the short distance that candlelight travels before it falls off into shadow.

Draw a Still Life With Cast Shadow

Let's get familiar with the Conté medium by experimenting with the white, gray and black Conté crayons. This type of drawing is called *achromatic,* or without color. We'll start by setting up a one-object still life and use the additive process to explore the mark-making characteristics of Conté crayon.

Select a white object, such as a white coffee mug, and place it on a white surface such as a tabletop or large piece of paper. Use the 25-watt bulb as your light source.

Study the setup for a few minutes before you begin the drawing. You're going to draw both the coffee cup and the cast shadow. As you study the setup, ask yourself this question: "How am I able to see what I see? What differences in value help to produce edges and shapes?"

Notice how the weak light source doesn't illuminate everything. You can see volume better on the light side than on the shadow side. There is no reflected light on the shadow side of the cup because the light isn't strong enough to bounce off a nearby object back onto the cup. Notice how the cast shadow is darkest at the base of the cup, where there's the maximum blockage of light, and how the shadow lightens as it moves away from the object.

The shadow edge is distinct and sharper near the base of the object and softens as it moves away from the object. The contrast of light and dark values and edges is more evident near the light source and less evident farther from the light source.

MATERIALS

PAPER
Charcoal paper

CONTÉ CRAYONS
2B Black
Gray
2B White

OTHER
Desk lamp with 25-watt bulb
Kneaded eraser
Stump
Tortillion
White object

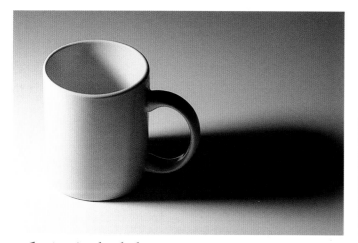

1 Examine the Shadows
Take a few minutes to really look at the still life. Examine the shadows, look for the hard or soft edges, observe the shapes that you see and determine where the shadows are darkest and where they begin to lighten.

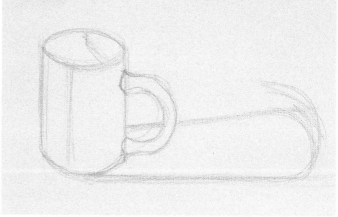

2 Create a Contour Line Drawing
On charcoal paper, start with the gray Conté crayon and draw the outline (contour) of the two objects with the end of the crayon. As your drawing progresses, gray will be easier to hide than black. Use light pressure with no erasing.

Once you've completed the contours, study the still life again, squinting to simplify what you see.

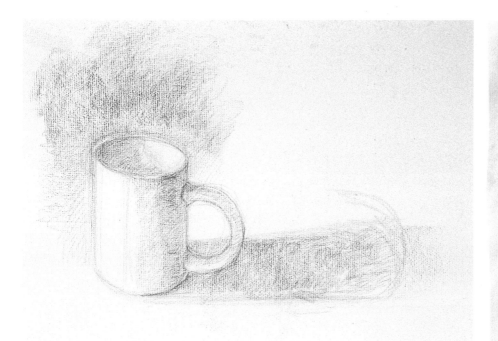

QUICK TIP

⌖ When you squint your eyes, you don't see any distracting colors, textures, description or details. This makes it easier to see values and value changes.

⌖ You may notice that the paper's texture makes it difficult to produce a flat value. This is because the Conté rides on the top ridges of the paper texture and picks up all the imperfections.

⌖ With repeated hatching and crosshatching, the initial hatched lines will gradually disappear and a tonal mass will be established.

⌖ The ability to create a passive flat-value background—one that does not compete for visual dominance—is an asset. A passive background directs the eye to the center of interest: the still life objects.

3 Block In the Darkest Areas
Use the side of the 2B Black Conté crayon with a delicate touch to lightly indicate the darkest areas without committing to the exact value. You can always darken the value later.

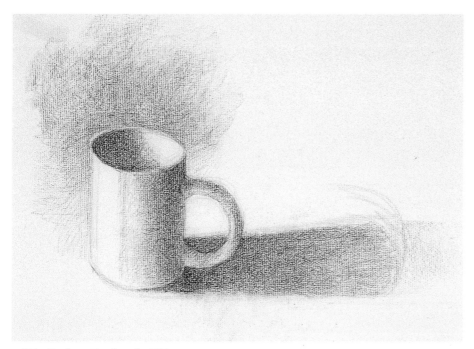

4 Begin to Darken the Values
You may have to combine layers to produce the desired values. With a light touch, hatch and crosshatch over the area that you want to darken. Using the tip of the crayon, gradually increase the pressure while keeping it even and under control.

QUICK TIP

✏ The grain of the charcoal paper makes it more difficult to create subtle value transitions when using just the additive method.

✏ Make the grain of the paper work for you by adjusting pressure, the number of layers you apply, and filling in the grain. With patience, you can gradually reduce the amount of texture affecting the value areas, and gain the control you want.

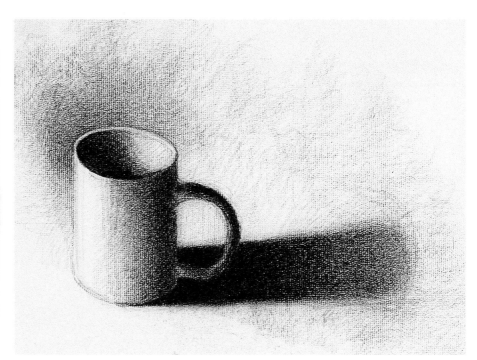

5 Continue Darkening the Values

Continue to hatch or crosshatch until you match the approximate values that you see. At this point, the white of the paper is mixing with the black Conté. Don't mix in any gray or white Conté. Bring this dark tone right up to and include the contour lines of the objects. The contour line disappears, but the object's silhouette remains.

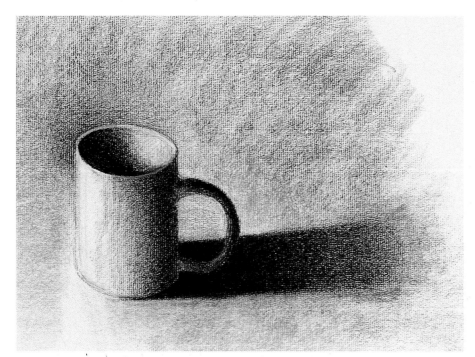

6 Final Stage

Slowly darken the background value by gradually increasing pressure with each layer. The grain of the charcoal paper remains a factor all the way through the drawing. At this point, you are still using only black Conté and the white of the paper. Create the value changes on the light side by adding gray and 2B white where needed.

MORNING RITUAL
Conté on charcoal paper
12" x 14" (30cm x 36cm)
Collection of the artist

Blending and Rubbing with Conté

Set up two simple objects, such as an apple and a Styrofoam cone, near the desk lamp. In addition to the additive process, we'll use the rubbing technique, smearing and blending in our drawing. Use charcoal paper and the various hardnesses of your white, gray and black Conté crayons.

Before getting started on the drawing, take a few minutes to find out how the Conté reacts to an eraser, rubbing with your fingers, and blending with a chamois. Now you'll know what to expect with each technique.

MATERIALS

SURFACE
Charcoal paper

CONTÉ CRAYONS
Black
Gray
White

CONTÉ PENCILS
Black
White

OTHER
Apple
Chamois
Kneaded eraser
Stump
Styrofoam cone
Tortillion

QUICK TIP

- Wear a visor or hat to shield your eyes from the light. Don't allow the light that illuminates your drawing surface to hit the still life.
- Constantly look back at the still life to refresh your memory of its values.
- Draw what you see, not what you think you see.
- To help you draw a straight line, set the Conté crayon on its side, oriented in the direction you want the line to go, then pull along its length.
- If you imagine lines on the top of each form and connect them to the end of the cast shadow, they will point directly to the light source.

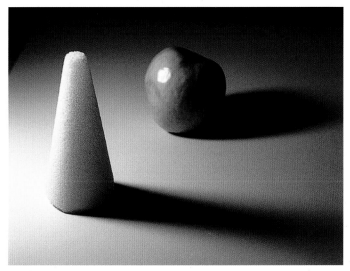

1 Your Still Life Setup
Arrange a simple still life similar to this one.

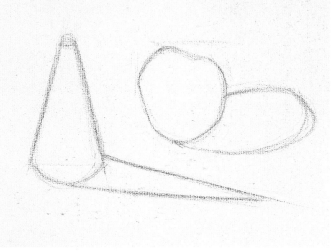

2 Create a Contour Line Drawing
Begin with a contour line drawing using gray crayon.

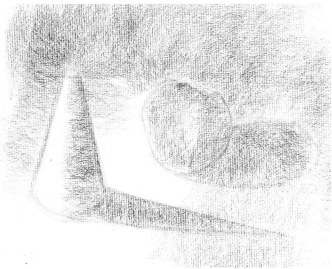

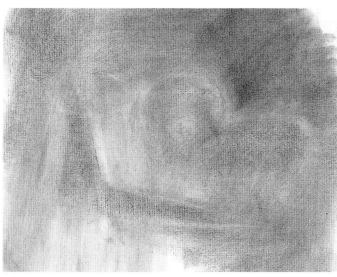

3 Begin the Background
Squint to see the background value. Use the side of the black crayon to create a nongrainy tonal mass that is the appropriate value.

4 Create a Flat Value
Use the chamois to blend the marks into a solid flat value. You'll notice the grain is gone, although the gray contour is still visible. You've produced a solid flat value for a passive background, in contrast to the grainy one created in the previous drawing.

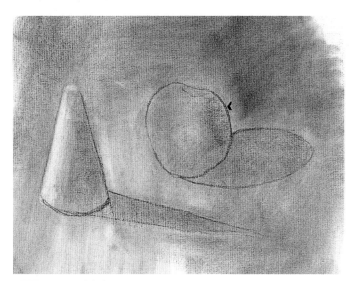

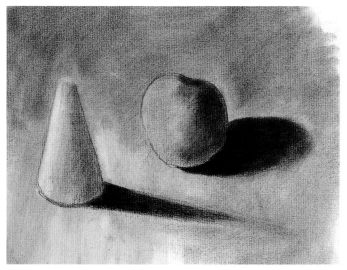

5 Re-establish Contour Lines
Re-establish your contour lines. Eventually, you will want the contour lines to disappear again as in the previous exercise. Reshape the light side silhouette using the kneaded eraser.

6 Work on the Shadow Side
Darken the shadow side by hatching, crosshatching and blending to reproduce the values that you see. Blend with a tortillion or stump to help solidify the flat tone and also help you to be a little more precise.

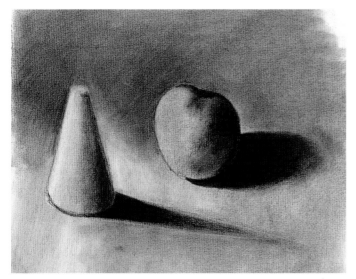

7 Adjust the Values

Continue to adjust the values. At this stage, you should have a solid, blended background. As a result of darkening the background, the light side appears to be lighter.

Start adjusting the light side of the forms, using any technique you wish to create form (e.g., hatching, crosshatching, rubbing, blending, erasing and lifting). If you don't have the right values, use a clean part of the chamois to rub out and neutralize the area, then redevelop it. Remember, the values on the illuminated side should be lighter than the shadow side and background values, and the Styrofoam cone should initially be lighter than the green apple.

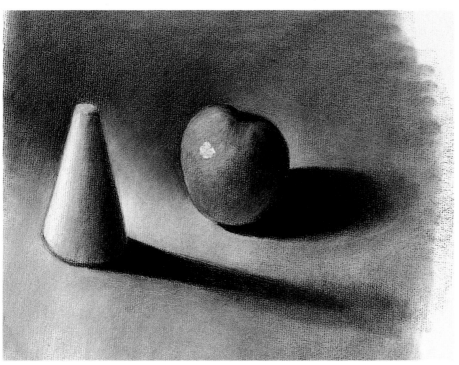

QUICK TIP

- Use a chamois, tortillion or stump to fill in the grain of the paper for greater control and clarity.
- During the finishing stages, step away from your drawing constantly to see how it looks. Standing or sitting close to the drawing allows you to see only a part, not the whole.

8 Finish the Drawing

Retain the lightest light (white) for the sides facing the desk lamp. The blended background makes it possible to create transitions and value changes. Subtle adjustments using light layers over darker areas show up on the blended background.

Using the white and black Conté pencils with a delicate touch, fill in any remaining lights and darks. If you make each adjustment minimal, it is easier to stay in control.

CONE AND APPLE
Conté crayon on Charcoal paper
14" x 16" (36cm x 41cm)
Collection of the artist

Let's Use Color

Red is the dominant color in this next demonstration, and the additives are white, gray and black. Remember that red, in its pure form, is a warm color with a specific middle value. White, gray, and black are cool colors; therefore, the addition of white, gray or black will change the original characteristics of the red.

In this demonstration, you're going to learn how pure color (red) appears to come forward in a drawing and how less intense colors—red with black and white added—appear to recede into the background. Use a smoother paper, such as a Strathmore drawing pad or other medium-textured paper. Notice how differently this paper texture responds to Conté than did the rough charcoal paper.

MATERIALS

PAPER
Drawing pad

CONTÉ CRAYONS
Black
Gray
Sanguine (red)
White

OTHER
Clean chamois
Desk lamp
Kneaded eraser
Two simple objects

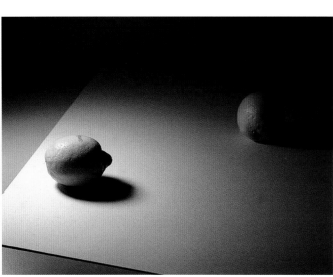

1 Set Up Your Still Life
Use a desk lamp for your light source. Place two simple colored objects, such as a lemon and an orange, on a sheet of white paper, at different distances from the light (one closer and one farther away).

2 Create a Contour Line Drawing
Using a red Conté crayon, draw the contours of the still life.

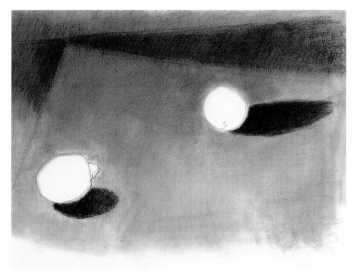

3 Blend the Background

Apply black Conté crayon to the background and blend to create a passive background. Be careful to keep the objects free of this color. Add the cast shadows at this time.

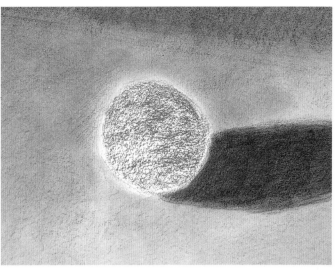

4 Add Red to the Objects

Use a red crayon to apply a thin red foundation to each object.

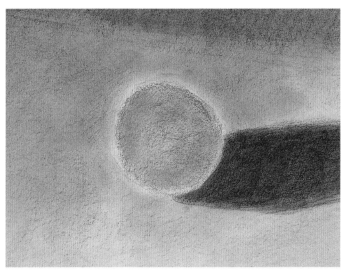

5 Blend the Red Foundation

Use a *clean* chamois to blend the red foundation of each object into a flat value. Your goal is to produce a clean, flat value that corresponds to the values you see in the still life.

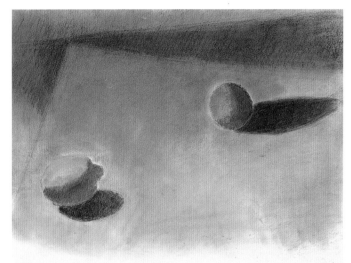

6 Work on the Shadow Side

Because the shadow areas are quite dark, you'll need to combine several layers of red and black on top of the red foundation to produce the correct values. Apply a hatched layer to the shadow side and blend with a tortillion.

Squint your eyes to evaluate the values and correct if necessary.

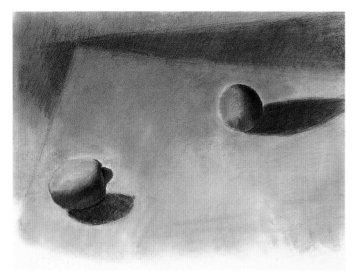

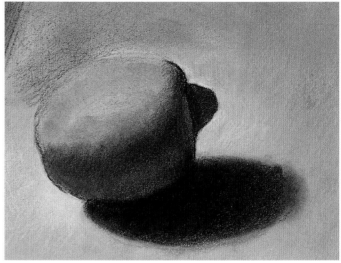

7 Add Layers and Blend
Add more layers and blend with your finger, as necessary, to retain and/or create darker layers and to gradually eliminate the white paper.

8 Bring Out the Cast Shadows
Make the cast shadows more apparent in your drawing. Observe where and how the light illuminates the paper around the edge of the cast shadow. Add a light layer of gray or white to this light area surrounding the shadows. By creating a lighter environment, you will make the shape of the shadow more apparent.

QUICK TIP

- Soften the shadow edge by blending over and over, using whatever blending tool works best for you.
- Sometimes the Conté may contain a hard piece of clay that scratches the paper. If you feel a particle or notice a scratchy sound, stop, remove the sharp clay bit with your fingernail or a razor blade, and continue with the drawing.
 A scratched line will appear darker no matter what you do to remove it from the drawing surface.

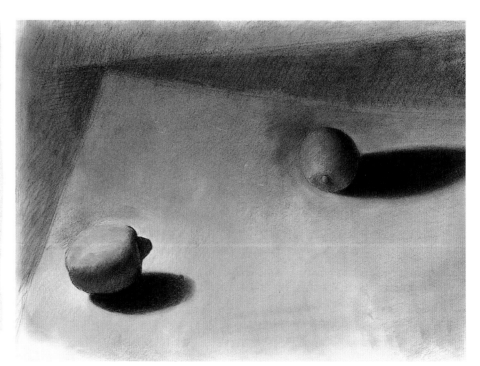

9 Soften the Shadow Edge
The shadow edge farthest away from the light source, created here by the orange, should be harder to see; whereas the closest shadow edge, created by the lemon, should be more defined. Therefore, to create an illusion of space and depth, make the shadow edge of the orange much softer than the shadow edge of the lemon. Continue to work on the shadow side until you are satisfied that you have reached the correct values.

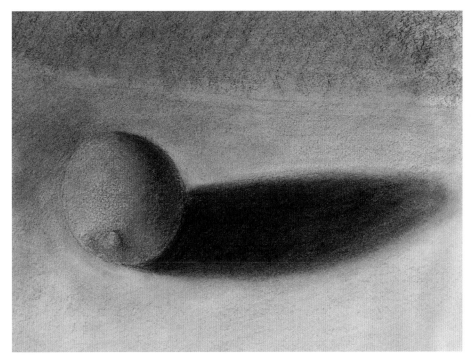

10 Reduce the Brightness

Keep the color of the object and the area closest to the light source clean and pure. Delicately hatch in white and gray Conté over the red to create a value transition on the illuminated side of the lemon. If you need to remove any marks, use a kneaded eraser.

To make the orange appear farther away from the light source, reduce the brightness of its color by carefully blending the light red area with a tone of black, using your fingers. Use gray and gray/black combinations with the red to increase the dulling effect and to create softer edges.

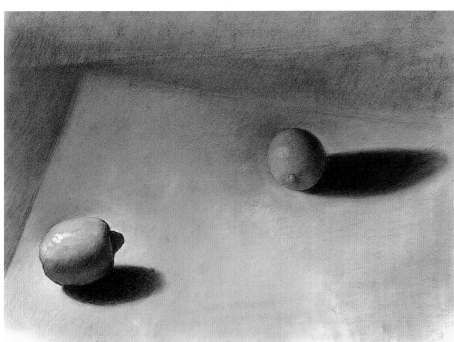

11 Finish the Drawing

Make the left edge of the white paper that the lemons are sitting on sharper as it comes forward, and softer as it recedes. Use a top layer of red Conté (because it's a lighter and brighter value) to create the reflected light area on the bottom of the lemon. Make subtle adjustments with a light, delicate touch until you are satisfied with the results.

CONVERSATION
Conté on drawing paper
16" x 20" (41cm x 51cm)
Collection of the artist

Using Candlelight

We've already practiced with daylight and incandescent lighting; this time we're going to use the third type of light we previously discussed: candlelight. To experience the full effect of candlelight, you'll need a completely dark room, or you'll need to draw at night. You'll have to use some sort of lighting system to see your drawing surface, such as a small reading light. Make sure to block this light from reaching your still-life objects. A clip-on book lamp offers less glare and can be clipped to the edge of the pad; so it may be the best choice.

This will be a monochromatic, subtractive drawing; that is, using only one color of the prepared ground (red) without the addition of any added white, gray or black. Therefore, it will have a restricted and reduced value range. The value of the red ground will be the darkest value, and the lighter values will be created by removing (subtracting) the red foundation to expose more and more of the white of the paper.

MATERIALS

PAPER
Drawing pad

CONTÉ CRAYON
Sanguine (red)

CONTÉ PENCIL
Sanguine (red)

OTHER
Candle
Chamois
Clip-on book lamp
Kneaded eraser
Soft white eraser
Two white objects
Value scale

1 Set Up Your Still Life
Select two white objects and place both on a flat, light-valued surface. Set a lighted candle about six inches (15cm) to the left and behind the first object, then place the second object about twelve inches (30cm) from the light source.

Turn out all the lights and allow your eyes to adjust to the darkness. Study the situation for a few minutes before you begin drawing. You're going to draw the candle as well as the objects.

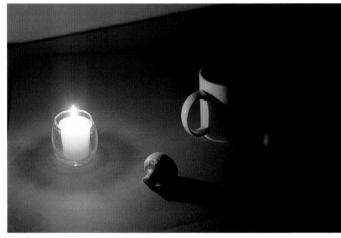

QUICK TIP

✐ You may have to turn on another lamp momentarily to check the progress of your drawing. Once done, go back to using the book lamp.
✐ Rather than completely committing to a dark line at the offset, start with a very light contour line that you can darken once you're satisfied with how it looks.

2 Blend and Flatten the Value
Use the side of the red crayon to lay down your foundation over the entire drawing area. Use the chamois to blend the foundation color into a solid, flat value and to keep the color clean and beautiful.

3 Darken the Foundation

If necessary, lay down additional layers of red and blend with the chamois until the paper grain is covered. Produce a dense foundation that can be lifted easily with an eraser, fingers, or a clean chamois. Remember, blending with a chamois eliminates the paper's ability to hold onto the Conté, as is the case with compressed charcoal (see chapter two).

The foundation value should be similar to a value 7 on the value scale.

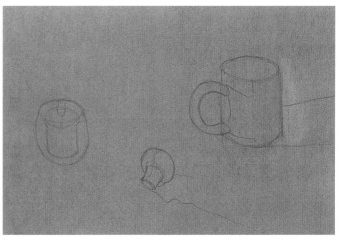

4 Create a Contour Line Drawing

Delicately draw the contours on the foundation ground with the red pencil. Correct any linear mistakes by using the chamois to blend and neutralize the area again.

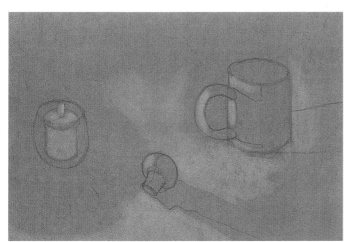

5 Remove Some Foundation

Once the contours are established, squint your eyes and look at the still life to see where the light values are located. Remember, you're not going to darken any further. The darkest value is already present in the prepared ground.

Begin to lighten the illuminated areas with the clean part of your chamois.

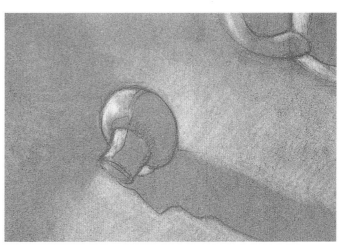

6 Lighten Values Using the Kneaded Eraser

Use the kneaded eraser when you need to whiten even more, but start lifting delicately. Erase using light pressure, lifting off the foundation ground in small increments to show value change. Knead the eraser to a point and lightly erase using a hatched line. This allows you to erase small amounts while still controlling the amount of foundation removed.

QUICK TIP

- By gently hatching and crosshatching with the kneaded eraser, you can remove small increments of pigment. This allows you to make subtle adjustments to the ground.
- For maximum removal, reknead the eraser to a clean tip before each erasure. Begin lightly and slowly, for more control over the amount of value that you remove.
- Use the soft white eraser to remove the maximum amount. Be sure to clean any graphite or charcoal remnants from previous drawings off the eraser first (by scrubbing the end surface clean on a scrap sheet of paper) so you won't soil the drawing.

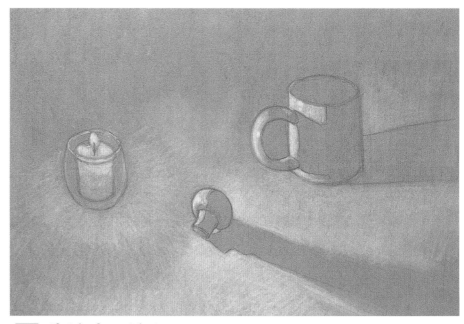

7 Lift Color from Light Areas

Continue lifting and erasing until you achieve the desired light values and white areas. You can see how important a uniform foundation ground is for the success of this drawing.

You will be pleased at what you accomplish by simply lifting the ground off the paper gradually exposing the lighter values underneath.

8 Add Red to Finish the Drawing

Evaluate your drawing. Add red Conté to the shadow side as needed to match the contour line value. The original blending with the chamois made the ground lighter and more translucent. Add layers of red Conté to the shadow areas so they appear darker and more opaque. This adjustment will also make the contour line in the shadow disappear and give the drawing more punch.

CANDLELIGHT SONATA
Conté crayon on Strathmore drawing paper
16" x 20" (41cm x 51cm)
Collection of the artist

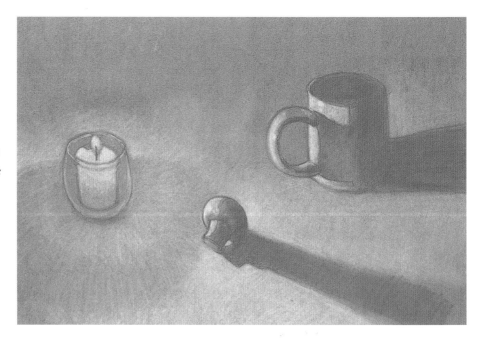

Adding to the Subtractive Process

This exercise uses a full range of values. You will need smooth layout paper for your drawing surface, and a variety of Conté crayons and pencils.

The lightest values are the white of the paper (using the subtractive process) and the white Conté crayon (using the additive process).

The gray Conté falls into the light-middle value range and the red (Sanguine) Conté, the middle value.

Next in value darkness you will use the brown Conté and the darkest value will be reached with the black Conté.

You will begin with a middle value red foundation and simply lighten by lifting (subtractive) or adding gray or white (additive). To darken the red foundation, you will use the darker red, brown or black Conté crayons.

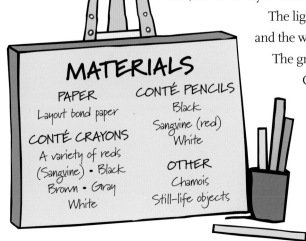

MATERIALS

PAPER
Layout bond paper

CONTÉ CRAYONS
A variety of reds
(Sanguine) • Black
Brown • Gray
White

CONTÉ PENCILS
Black
Sanguine (red)
White

OTHER
Chamois
Still-life objects

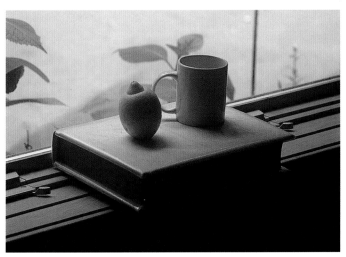

1 Set Up a Still Life in Natural Light
Set up a still life containing three different objects in natural light. Set your still life near a window and close the shades or drapes on any other windows so light comes from only one direction.

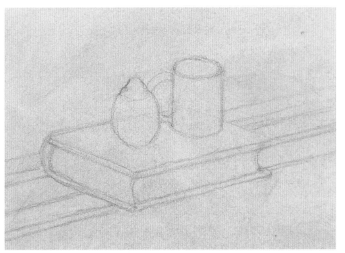

2 Create a Foundation and Contour Drawing
Prepare the foundation with red Conté crayon using the same toning procedure that you used in the last drawing. Use the side of the crayon to apply a layer of red and use the chamois to blend and create a consistent flat value. Then create a contour drawing of the still life.

QUICK TIP

Squinting keeps the eye from seeing details, descriptions and colors, allowing you to concentrate on value. When beginning any drawing, concentrate on establishing the correct values before developing anything else in the drawing. Detail is the last item to include in any drawing.

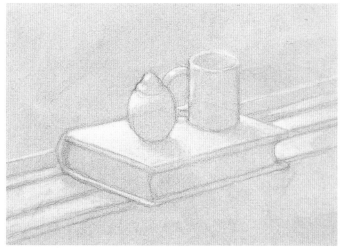

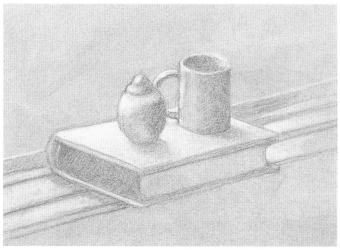

3 **Subtract the Foundation Ground**
Look at the still life and squint your eyes to see if any values are lighter or darker than the red foundation value on the paper. Begin by subtracting the foundation ground with the chamois or your finger to create the lightest values in your drawing.

4 **Add the Middle Values**
Add the middle values (using the red crayons) to increase the value range in your drawing. Make slight adjustments with the pencils.

QUICK TiP

Follow these steps to build a strong drawing every time:

1) Create the contour drawing
2) Add light
3) Model form (shadows and shading)
4) Add detail

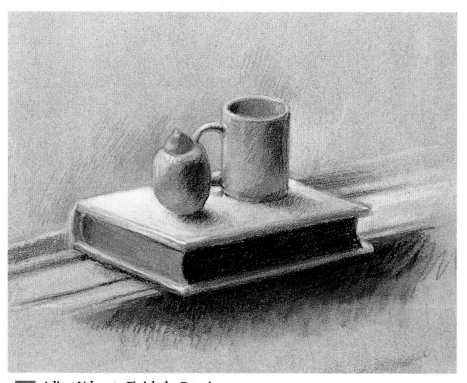

5 **Adjust Values to Finish the Drawing**
Add the darker values to complete the shadows and darkest darks. Squint again to see whether your values are accurate by comparing the values in the still life with the values in the drawing and vice versa. Keep squinting while comparing the values in the still life to the values in your drawing. Adjust the values accordingly to complete the drawing.

STILL LIFE WITH LEMON
Conté crayon on layout bond paper
11" x 14" (28cm x 36cm)
Collection of the artist

Drawing on a Colored Ground

Here is a more complex object to draw: the model of a human head. By following the same rules that we have been following all along, you will find a head just as easy to draw as any other object.

For this drawing, you won't have to prepare the surface ground, because the paper already is a certain color and value. Unlike the previous exercise, you will be unable to lift the color off the paper to expose the light or white value. The paper's color and value stay constant as a foundation value unless a lighter value such as white or gray is added to the paper.

MATERIALS

PAPER
Canson Mi-Teintes, no. 341, medium-value Gray

CONTÉ CRAYONS
Black
Sanguine (red)
White

CONTÉ PENCIL
White

OTHER
A complex white object
Dominant and secondary incandescent light sources
Roll of tape
Standing lamp
Styrofoam ball

The object of this exercise is to add color only to those areas where the values will eventually become lighter or darker than the value of the paper. Try to keep the areas that match the value of the paper clean. Lighter areas will be altered and lightened in value by adding the white and gray Conté. Dark areas will be created by hatching and crosshatching with black.

Choosing and adjusting your lighting is very important. I have set up the still life using three different lighting situations in order for you to see the difference lighting can make. For this exercise, an incandescent light source is the best choice for capturing the structural form of each object.

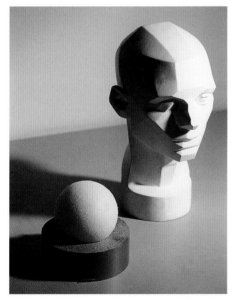

Concentrated Light Source
I used a 150-watt bulb for the dominant light source and positioned it above and to the right of my still life. This type of light is called concentrated light and produces a dramatic difference between the light and dark values, as well as a definite shadow boundary.

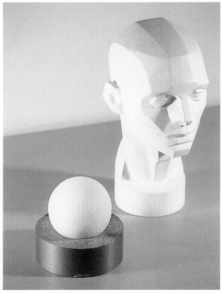

Secondary Light Source Too Close
This secondary light source is too close and too bright; the wattage should be less than that of the dominant light source. A second bright light can cause some surface confusion and make the structure less obvious.

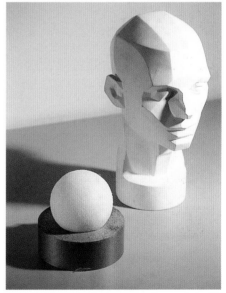

Incandescent Source
Set up another still life using incandescent light as the light source. Make sure the dominant light comes from one direction only. This drawing is best done at night, or in a room with drawn shades. Include a secondary, weaker light source on the opposite side to help produce a reflected light effect.

Move the secondary light source until it helps to show volume in the forms. The two light sources should never be the same strength or at the same distance from the subject; one should be stronger and closer than the other.

71

1 Create a Contour Line Drawing

Use the red crayon to create a careful contour line drawing on the medium-value paper. Use the contours to create a linear diagram to help you decide where to place your lights, middle values and darks.

This sculptural form is more complicated than previous simple forms. You'll want to take your time to measure proportions and line up everything. Be patient; you can do it.

QUICK TIP

The medium value of the paper is important because it is used as a medium value in your drawing. Continue squinting, comparing and adjusting the light values until you think every value is correct. Check and recheck carefully and often.

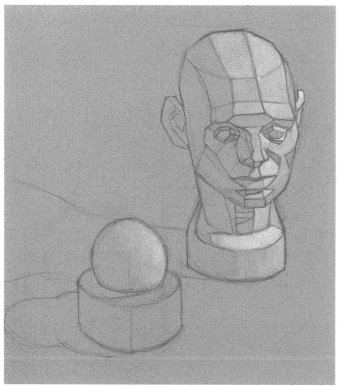

2 Apply the First Light Areas

Use the white pencil or crayon to hatch, crosshatch and blend the values on the light side of the form. Begin with a light application and gradually increase the density. Continue to lighten the value with additional hatching and crosshatching.

Create a uniform and consistent flat value without overcommitting. Match all the identical lighter values (lighter than the gray of the paper) before moving on to the lightest ones. Keep the pencil sharp to fill in the pores and create a uniform and consistent tonal mass. The more pores you fill, the whiter the value becomes.

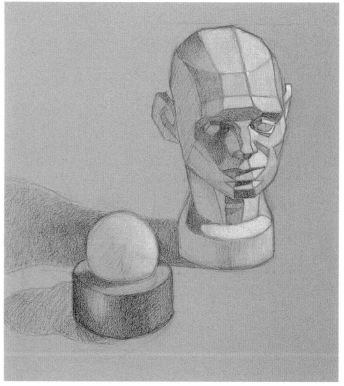

3 Create Middle Values

Once you're sure the lights are accurate, work on the medium values using a light touch and black Conté. Leave the gray paper bare when you think it matches the value of your still life.

Use a stump or tortillion to blend the added pigment into a solid tone and to eliminate the gray of the paper showing through.

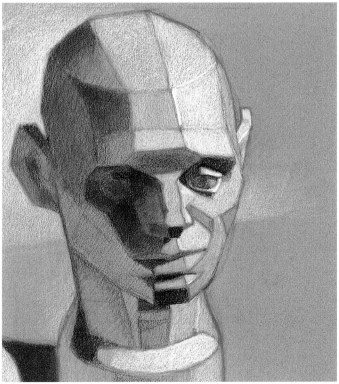

4 Add the Darker Areas

Add the darkest values and blend to eliminate any grain in this area. Stand back to evaluate your drawing; if needed, adjust the light and dark areas to clarify.

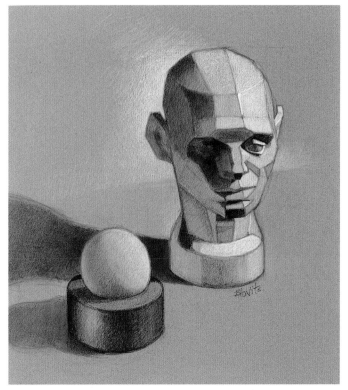

5 Finish the Drawing

Since the ball and roll of tape are the closest to the viewer, they should have more information, detail and pure color. The background should be softer and not as detailed. Reinforce the values and structures in the foreground. Clarify the planes of the head. Stop when it looks like everything works together and you've reached your goals for the drawing.

I GOT MY EYE ON YOU
Conté crayon on Canson Mi-Teintes paper
22" x 18" (56cm x 46cm)
Collection of the artist

QUICK TIP

TO CREATE DEPTH:

✐ Place the most information and detail in the foreground, and minimize the background

✐ Blend the background texture to a smooth and passive flat value; leave the texture evident in the foreground objects

Pastel

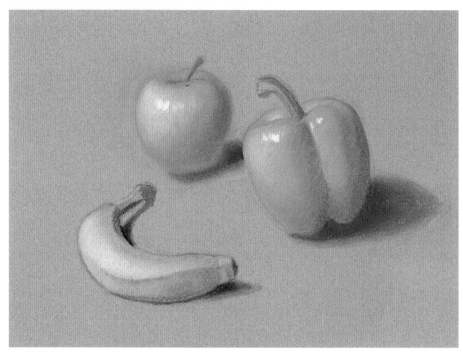

In this chapter we're going to move into full color, following the same procedures used in the previous chapters. To do the exercises in this chapter, you'll need a set of pastels with a variety of colors including brown, black, white and different shades of gray. You can buy your pastels separately or buy a quality pastel set.

Pastels come in many different densities from semihard to very soft. Popular sets include Nupastel, Faber-Castell, Cretacolor, Holbein, Rembrandt, Grumbacher, Rowney, Sennelier, Schmincke, Girault, Unison, Great American Soft Pastels, Winsor & Newton, as well as some very fine handmade pastels made by people like Terry Ludwig and Paul de Marrais. Semihard Nupastels were used throughout this chapter because they're easy to use, easy to find and because of their density, you can sharpen each stick to a point. Talk to your art supplier about the set that is best for you.

DIETER'S LUNCH
Pastel on Canson
Mi-Teintes paper
16" x 20"
(41cm x 51cm)
Collection of the artist

SHOPPING LIST

PAPER
Two sheets Canson Mi-Teintes, 19" x 25"
(48cm x 63cm) no. 341 Steel Gray
One sheet sandpaper for pastel, 19.5" x 27.5"
(50cm x 70cm) neutral-colored
Strathmore Layout Bond paper, 14" x 17"
(36cm x 43cm), 16 lb. (35gsm) white, or comparable
smooth, lightweight, all-purpose bond paper
Drawing paper

DRAWING MATERIALS
Pastel set with at least 24 colors

OTHER
Craft knife or single-edge razor blade
Kneaded eraser • Spray fixative for pastels
Tortillion • Stump • Wet/dry sandpaper

Characteristics of Pastel

Pastels are made from pure powder pigment that is mixed with a binder (gum tragacanth) and compressed into stick form. The hardness or softness of the stick is controlled by the amount of binder added; the more binder added, the harder the stick. Most brands of hard pastels are identifed by the numbers imprinted on the sticks.

In the case of the Nupastel stick, some of the binder migrates to the exterior and produces a hard, shell-like surface. Once this hard surface is removed with fine or wet-dry sandpaper, you can apply the pastel easily.

Pastel manufacturers often add white or a lighter-value pigment to lighten a color, or they add black or a darker-value pigment to darken a color. You'll have to do the same to alter the colors in the following demonstrations and exercises.

Pastel Sticks
Pastel sticks are made from pure powder pigment that is mixed with a binder (gum tragacanth) and compressed or formed into sticks. Sharpening the harder Nupastels (shown here) removes the outside shell and allows for easier application to the paper surface.

Use Sandpaper to Eliminate the Shell
Rubbing the side of the pastel on a rough surface, such as fine or wet/dry sandpaper, eliminates the hard outside shell.

Create the Perfect Point

The outside shell of a pastel stick appears darker than the actual value of the pastel. Sharpening one end of the stick exposes its true value.

MATERIALS

PAPER
Any scrap paper

PASTELS
Any color

OTHER
Craft knife or single-edge razor blade

Find the Reference Number
Look for the number on the pastel stick; you want to sharpen the opposite end.

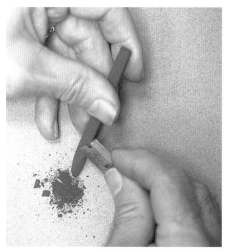

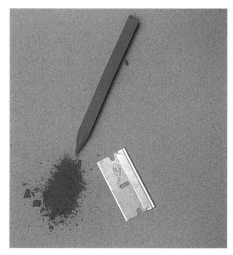

1 Sharpen the Pastel
Use a new single-edge razor blade or craft knife to sharpen the pastel. Place the end to be sharpened (the end without the identification number) on the scrap paper surface. Supporting the pastel stick this way will help prevent crumbling. Slowly cut off each corner, starting with the outside edge, cutting in and down toward the center with the intention of eventually producing a point.

2 Continue Cutting Corners
Continue rotating to cut off each corner. Do this carefully so that the tip doesn't crumble. An old, dull blade makes sharpening much more difficult and crumbling is inevitable.

3 Be Patient
When all the corners have been cut, continue to rotate and shave until you form a point. Be patient and careful during this procedure, as some pastels are softer than others.

Using Pastels

For most of our experimentation with pastels we will use the additive drawing process; the eraser isn't as useful or necessary with this medium. Pastel is an opaque medium; therefore we can cover all previous strokes and revise without lifting or erasing. Pastel is so forgiving, you can usually hide all your mistakes!

Mixing Colors

When you mix colors by hatching and crosshatching rather than by blending, the resulting color will stay brighter and cleaner. Rubbing dulls the color. It's okay for the foundation, but not for the top layers.

Laying the Foundation

It is important to set up a strong foundation with pastel and to eliminate the grain of the paper. If your beginning-color areas don't appear solid, rub them in with your fingers, a tortillion or a stump. If the area still doesn't appear solid, apply additional layers of pastel and blend again. You need a dense pastel base; a weak base doesn't contribute to the building process.

QUICK TIP

When deciding on the correct value for your foundation, squint, then make the base value slightly darker than you think it should be.

You can always lighten the value with white. Chalkiness often results when you try to darken a value, so start darker and lighten!

First Stroke
The first blue mark is made on the textured side of Canson Mi-Teintes paper. Notice the pronounced texture.

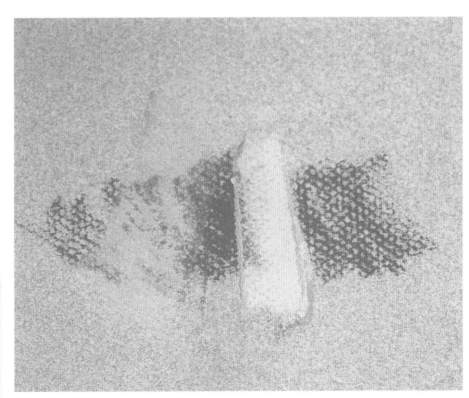

Partial and Full-Covering Strokes
Because pastel is an opaque medium, you can partially or completely cover previous marks by overlaying them with more strokes. Correction is easy and there's no need to erase anything.

In this example, the lightly stroked orange overlay on the left is semi-opaque; you can still see some of the blue underneath. The orange overlay on the right was made with more pressure, and thus, as you can see, is more opaque; it covers the blue mark.

Notice Hatching vs. Blending

Notice the difference between the hatched mixture on the left and the blended (rubbed) mixture on the right.

Rubbing Dulls Hues

The vibrant blue on the left side was directly applied. The same blue on the right isn't as vibrant because it was rubbed. Rubbing lowers the intensity of a hue.

Build a Solid Base

Don't be afraid to lay down a solid foundation. The paper grain may affect the value of your foundation if the white shows through the color. You can eliminate this grain by rubbing or blending with a tortillion, a stump or your finger.

The Characteristics of Color

Remember that color has four distinct properties: *hue* (the actual color, such as red), *value* (lightness or darkness), *intensity* (brightness or dullness) and *temperature* (warmth or coolness). When using color, we have to be conscious of these properties at all times.

The Color Wheel

The natural colors seen in the spectrum can be replicated by making a color wheel. A color wheel begins with the three *primary colors*: red, yellow and blue. When two primary colors are mixed in equal amounts, *secondary* colors are created: orange, green and violet.

Each color on the color wheel has a *complementary color*: a hue directly opposite on the wheel. When complementary colors are physically mixed they produce a color called *neutral gray*. *Neutral* means that it's neither of the colors you mixed (such as orange or blue) even though mixing these colors—in equal tinting strength—created it.

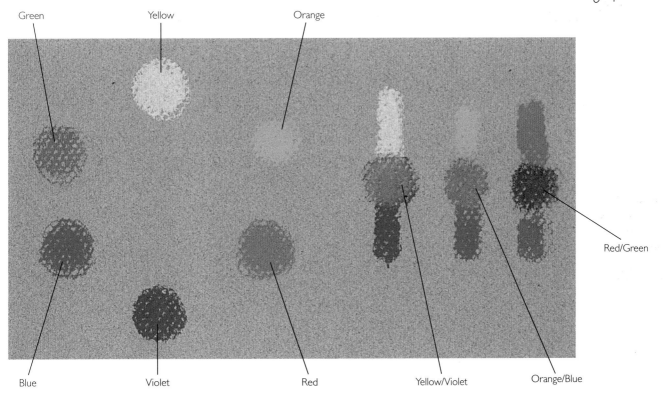

Green Yellow Orange

Red/Green

Blue Violet Red Yellow/Violet Orange/Blue

Complementary Color Mixing

On the left is a basic color wheel. On the right are three sets of complementary colors (yellow and violet, orange and blue, red and green) that, when mixed together in equal tinting strengths, produce a neutral gray. This is not to be confused with the achromatic medium gray created by mixing black and white. Colors created from combinations that are not mixed in equal amounts are called semineutral colors.

You can learn to see color. You are looking at six colors that fall into two categories: red, yellow and blue (known as the primary colors) or the secondary colors of orange (yellow and red), green (yellow and blue), or violet (red and blue). All the colors you see in nature fall into these categories, either as a pure color or as a semineutral color (including neutral gray).

Semineutral Colors

Bright colors are active and vibrant, while semineutrals and neutrals are not. You can use the contrast between pure and semineutral colors to create the illusion of space in your drawings. When compared to a pure color, a semineutral color will appear to recede; a neutral gray will appear to recede even more.

A bright color will also catch the viewer's eye, whereas a dull one will not. This is useful for creating a center of interest.

Color can also create the illusion of form and structure. Use pure hues and slightly grayed semineutrals for the highlights and light midtones; semineutrals in the middle, middle-dark, and reflected light areas; and neutral grays in the dark and deep shadow areas (see Creating Volume, page 43).

WORDS TO KNOW

NEUTRAL GRAY A color created when complementary colors are mixed together in equal amounts.

SEMINEUTRAL Complementary colors mixed together in unequal strengths, so that one or the other dominates.

PURE HUES

SEMINEUTRALS

NEUTRAL GRAYS

ACHROMATIC GRAYS

Colors, Neutrals and Grays

On the top row are pure hues of yellow, orange and red. The colors immediately below are semineutral colors because each has its complementary color mixed with it, but they are not of equal tinting strength. (For example, the yellow is mixed with violet but the mixture contains more yellow). When the tinting strength of mixed complements is equal, the resulting color is called a neutral gray (third row). Notice how each neutral gray is different. The grays in the bottom row are produced by mixing black and white together; they are called achromatic (without color) grays.

Pastel Paper

Pastel requires paper with a tooth, usually a medium-textured surface that will hold the pastel pigments. Experiment on the layout, drawing, and charcoal papers you already have.

Layout bond paper is very smooth; therefore it won't hold many layers of pastel. Drawing paper however, has a little more tooth than the layout bond and will hold more pastel. Charcoal paper is the most suitable of the three because it has the most texture. You'll find other papers, such as Canson Mi-Teintes, that also are well-suited for pastels. We'll also try a new type of paper in this chapter: sandpaper.

You'll find that a white surface can be a difficult one to use with pastel for a couple of reasons. Every pastel color is darker than the white paper (according to the value scale on page 14). Also, the white of the paper showing through a lightly applied color affects the values. Experiment with different papers as you become more comfortable with pastels.

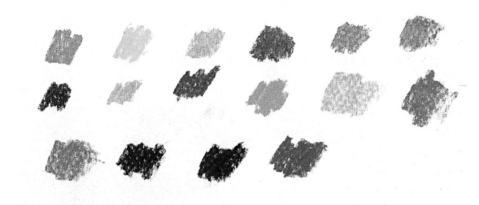

Every color value looks darker on white paper; therefore, it's more difficult to judge whether the relationships between colors and values are correct.

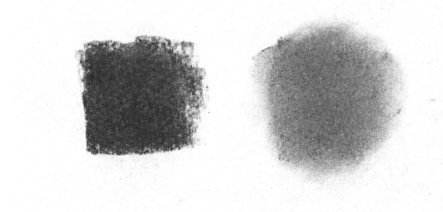

Firm pressure creates a dense application (as shown at left) and shows the true color and value of the violet. The same hue on the right looks lighter because the white of the paper shows through the thin, translucent layer.

WORDS TO KNOW

TOOTH The texture or grain of a drawing surface.

TRANSLUCENT The quality that allows the white of the paper to show through tonal layers.

How To Create Believable Space

How do you create believable space in your drawings? Understanding how we see will help you to create a believable illusion of space (depth) in your drawings.

When our eyes focus on a specific object, anything not being focused on is blurred and out of focus. As you look around, your eyes constantly refocus on each object you look at, blurring all other surrounding objects. Look around to experience this for yourself.

Look at an object in one of the pictures below, then raise your arm, positioning your index finger visually in front of that object. Concentrate on your finger and you'll see that it is in focus and everything else is out of focus. Now, keep your finger where it is, but concentrate instead on the objects in the background. Your eye automatically refocuses on the background and your finger is out of focus. Using this information can help you create and control the illusion of space in your drawings and prevent your compositions from looking flat.

Once you understand this auto-focus phenomenon you can intentionally choose to place foreground items in clear focus and background items out of focus. An object slightly behind another object is drawn so that it appears slightly out of focus, and an object farther back in space is drawn more out of focus and so on.

There are two key words to remember in creating the illusion of space or depth: *diminution* (objects diminish or appear smaller as they recede) and *reduction* (details fade or disappear as they recede). We'll practice these techniques throughout this chapter.

WORDS TO KNOW

DIMINUTION *Occurs when objects of equal size appear smaller as they recede into the distance.*

REDUCTION *Occurs when details fade as objects recede into the distance.*

A

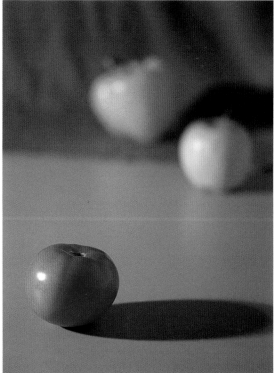

B

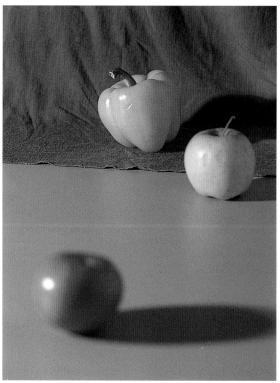

What Your Eyes See
When you stare at the foreground object (fixed gaze), you see everything about that object: color changes, textures and details. However, the background objects are out of focus (A). And when your eyes focus on the background objects, everything in the background is now clear, but the front object is out of focus (B).

Wherever you look, your eyes automatically focus for that distance.

Orange Still Life on Layout Paper

For your first drawing with pastels, you will use just a few colors and both the additive and subtractive drawing processes. As you saw in the previous chapter, you can create an image by simply lifting with the fingers or by using an eraser.

Select an orange as the subject for your still life and choose two complementary pastel colors, a deep orange and a deep blue.

Use natural light for your light source. If it is an overcast day you will get to to experience the characteristics of diffused lighting. Take the orange apart, then set up your composition with rind and all.

MATERIALS

PAPER
Layout bond paper

PASTELS
Deep Orange
Deep Blue
White

OTHER
An orange
New kneaded eraser

Still Life
The orange still-life setup in natural light.

Create the Foundation and Contour Line Drawing

Using the side of the orange pastel, lay down a coat of orange over the layout paper. Rub the pastel with your fingers to eliminate the grain, blending the pastel into a solid, consistent tone.

With the sharpened end of the orange pastel, create a contour line drawing of the orange. You will barely see the difference in value between the contour line drawing and the foundation. This line should disappear as you further develop the drawing.

2 **Lift to Expose the White Areas**
Use a new kneaded eraser to carefully and gradually lift the orange foundation outside of the contour lines to expose the white areas of your composition. This process separates the white areas from the subject matter.

3 **Create Volume and Highlights**
Use the eraser to delicately lift off some more foundation (less than in the previous step) to create the light (illuminated) side of the orange and peel.

Continue removing more of the foundation to create variations on the light side (the lightest part of the orange). The white of the paper, the value of the foundation and the value transitions in between, all help to create the illusion of volume on the light side. Both the highlights and the light halftones are the white paper showing through the foundation in various degrees.

4 **Indicate Shade and Shadows**
When the mid-tone values of your still-life orange are correct, leave them undisturbed.

Begin indicating areas of shade and shadow by lightly hatching some deep blue into the foundation on the shadow side. The drawing is starting to come alive just by producing these three values: light, middle and dark. Don't get too detailed at this time; keep your drawing loose. Remember, if the foundation value matches the mid-tones in the orange still life, leave it.

5 Continue Working on the Shadow Side

Continue adding additional layers of blue to create the shadow and cast shadow areas, beginning with the darkest area first. You may have to increase pressure to create a darker tone. Because the paper has little tooth, it won't hold the pastel very well. Hatch and crosshatch to create as consistent a tone as you can.

Continue to work on the transition of values in the shadow areas. The blue should match the value in the shadows; you shouldn't need to add black.

Pastel stains paper, so you may need to use white to lighten values on the light side if you couldn't accomplish it with the eraser.

Add the darker halftones by layering alternatate hatchings of blue over orange and adding additional layers until you reach the value you want. Always start with light pressure and gradually add additional layers of hatching or pressure as you see fit. You will produce a combination color that is somewhat neutral in hue, neither orange nor blue.

Keep looking back at the still life for information and direction. Don't look at your drawing too long before looking back and studying the still life.

QUICK TiP

- ✐ Squint your eyes to focus on the value differences, not the detail.
- ✐ Don't be surprised if you can't remove all the orange ground. Pastel does stain the paper.

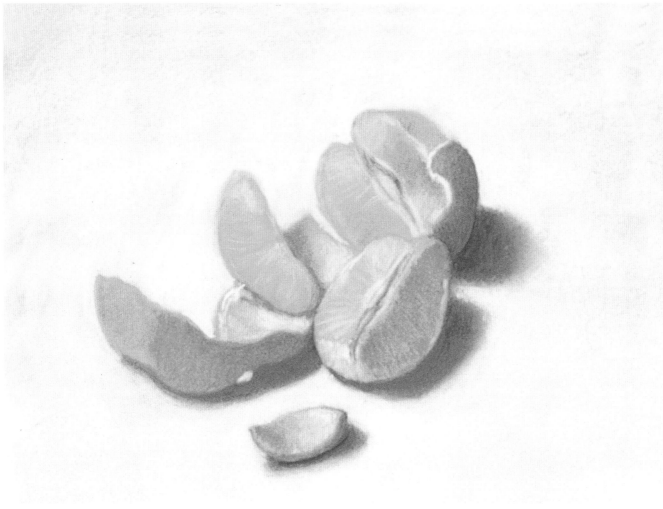

6 Add the Final Touches

Finish the drawing by adding subtleties and details. I think you'll agree that there is a limit to what can be done with this paper.

ORANGE MEDLEY
Pastel on layout bond paper
8" x 11" (20cm x 28cm)
Collection of the artist

QUICK TIP

Keep your drawing area clean. Vacuum the powdered pigment sitting loosely on the drawing surface with a round hose extension, holding the end about a half inch (1cm) away from the drawing. Be careful not to get the hose too close to the paper.

You might want to add a soft screen covering over the end of the hose to prevent sucking up your pastel sticks!

Flower and Apple Still Life

For the second exercise you will be using drawing paper. This time you're not going to use the eraser at all, but you may do some blending with your fingers. You will use the additive process for the majority of your development and revisions.

Rather than first creating a foundation ground as you did in the previous exercise, in this drawing you will gradually cover the white paper with layers of opaque pastels. You'll quickly find that because the drawing paper does have a slight tooth, it will hold the pastel better than the layout paper.

MATERIALS

PAPER
Drawing paper

OTHER
Still-life objects

PASTELS
Brown or Sepia
The rest of your
pastel set as needed

QUICK TIP

- To gradually darken a value, intersect the open spaces between the previous hatched lines with newly hatched lines. It isn't necessary to increase the pressure while applying these lines; just decrease the open spaces.
- When using an opaque medium like pastel, work from dark to light. Create the darker areas first, then gradually move to the lighter areas.

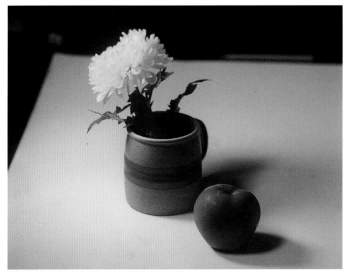

Arrange the Still Life and Light Source

Choose a complex form, such as a flower, along with another simple object or two. This time use incandescent light as your one light source. It's very important to make sure that the chosen light source is the only one illuminating the still life.

Create a Contour Drawing

Choose a neutral color, such as Brown or Sepia, and create a loose contour line drawing of your setup.

Never use white, black or a bright color for the beginning sketch. White and black are difficult to hide, while light and bright colors act like a neon sign.

Surrounding Color Effects
Each color is affected by the colors surrounding it. The color of the stick that you select from your set may look like a different color when applied next to another hue. Remember that nothing has to be perfect in the beginning. Make the initial color marks, evaluate the color and values, then revise as needed.

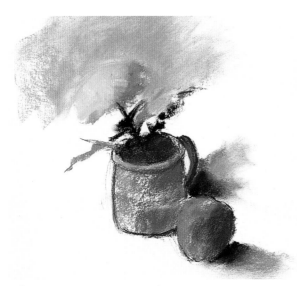

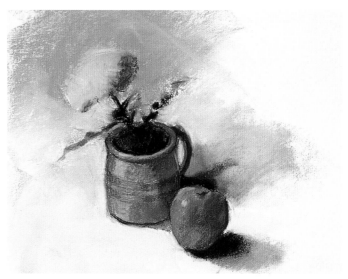

2 Set Up a Strong Foundation

Begin adding color by blocking in the colors you see, working from dark to light. Use the side of the pastel as much as possible; your goal is to produce a simple, solid-color base. Make your best guess at this point; don't try to create a finished product. Don't worry about the contour lines or the way the drawing looks. You'll restate everything a number of times.

If your beginning color areas don't appear solid, rub them with your fingers, a tortillion or a stump. If the area still doesn't appear solid, apply additional layers of pastel and blend again. Your goal is to set up a strong foundation and eliminate the grain of the paper. For the best results, create a dense pastel foundation, not a thin one.

Stop and vacuum the excess pastel dust often; you'll keep your drawing area cleaner longer.

3 Restate Your Colors and Values

Once the initial foundation is created and you've evaluated the color relations, go back and revise each area. Any questionable areas and colors will be covered over and hidden by the additional layers of pastels.

Continue to go back and restate all your colors and values, and remember to look up at the still life often. Squint your eyes so you can concentrate on color identity—squinting eliminates the texture, description and detail. If you think you see a certain color, don't question yourself; put it down. You may have to adjust the the value of the color. Just respond to what you see.

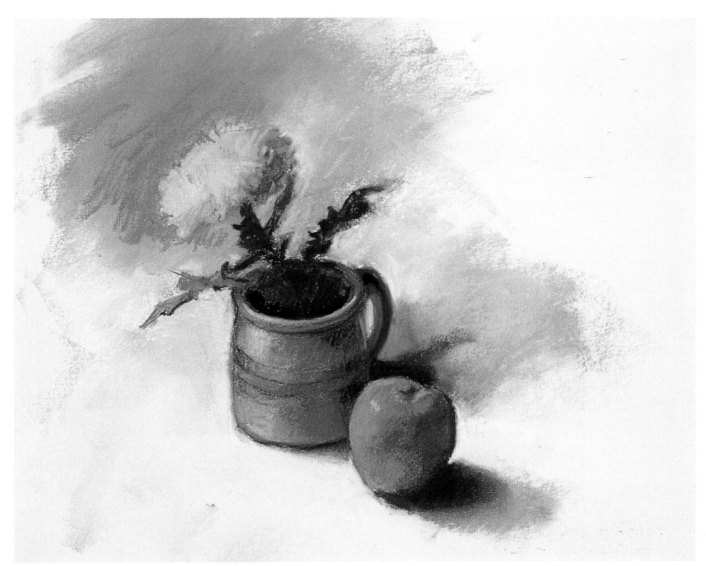

4 Add the Details

In the foundation stage you applied simple masses of color. Develop this further by paying attention to the effects of the incandescent light on the still life. Create the lightest areas by adding white or a lighter-value colo; darken the value of the midtones by mixing them with their complements; create the darkest darks by adding the complement and black. Keep the development simple at every stage without committing to a finished statement.

Once you are satisfied with the foundation colors, structures and forms, add the details. Then congratulate yourself—you're finished!

SUMMER TREATS
Pastel on drawing paper
13" x 15" (33cm x 38cm)
Collection of the artist

QUICK TIP

- ✎ Don't be discouraged if your color choices in the second stage aren't accurate. This is normal. Your color and value choices will become more accurate as the drawing progresses.
- ✎ Each pastel stick is one color, one value level, one level of intensity and one temperature. When you adjust a hue to lighten or darken it, you also add the characteristics of the new, added color.

Pastel on Charcoal Paper

You will be using white charcoal paper for your next drawing; it has a little more tooth than the drawing paper and will hold the pastel better than the other papers you've tried so far. As you already know, working on white paper is a little difficult, so we're going to tone this paper with a neutral color.

We can combine two complementary colors to create a neutral gray. Each color has a different intensity, some stronger and others weaker. Through the experience of mixing colors, you'll discover what percentage of each color to add to its complementary color to create that elusive neutral gray.

MATERIALS

PAPER
White charcoal paper

SUGGESTED PASTELS
Yellow (3 different values)
Violet (a blue-violet)
Plum (a red-violet)
Burgundy (a red-violet)

White
Black

OTHER
A sheet of neutral gray paper for placement under the still life
Still-life objects

1 Prepare the Foundation
Use two complementary colors. Since you previously used blue and orange, try yellows and violets. Side-stroke violet all over the paper.

2 Add a Complementary Color
Apply the complementary color, your lightest yellow, on top and then repeat the procedure. You've already begun mixing the colors by applying one layer of pastel over the other. By this time, the combination should start taking on the look of a neutral gray. Feel free to blend the colors with your fingers. You want to eliminate the grainy look of the paper. Blend both colors together to produce a solid, passive background color.

3 Keep Layering
If one color dominates, then you've discovered the color with the strongest intensity and you'll have to add more layers of the complement to reach the neutral gray. Keep trying until you create a color foundation that is neither yellow nor violet.

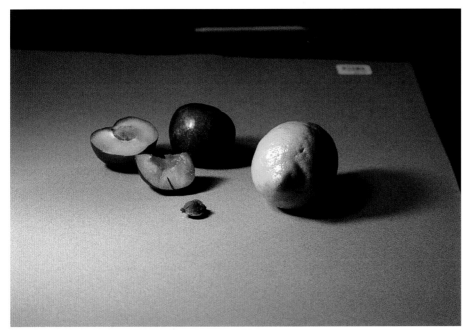

4 Set Up Your Still Life

It's time to set up the still life. Use an incandescent light as your light source. For the sake of unifying colors, choose two items that are yellow and violet, such as a lemon and a plum. To add interest, cut the plum in two so you can see the pit. Set these items on a sheet of gray paper, preferably one that is close to the same value and color as the neutral gray foundation, already created.

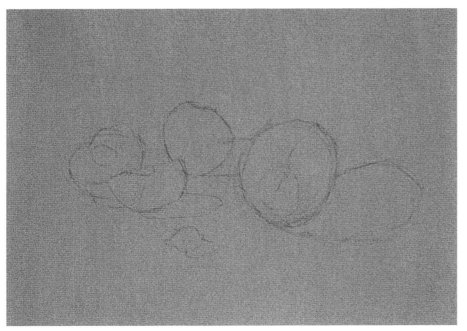

5 Create the Contour Line Drawing

Start with a light contour line drawing of your still life using the Violet you used to create your foundation. It's darker than the yellow, so you'll be able to see your lines on the neutral gray ground.

QUiCK TiP

- When creating the initial loose contour line drawing, start with a very light touch, creating contours that you can just barely see. Increase the line pressure slightly when you make revisions and corrections. Light lines will disappear as you build the drawing; heavy lines will not.
- Since you've learned how to make a neutral ground, the white of the charcoal paper won't be a problem. It's not always important to have the right color surface on hand; you can make it yourself by applying color mixtures to white paper.

6 Block In the Darks

Block in the dark areas using the Violet.

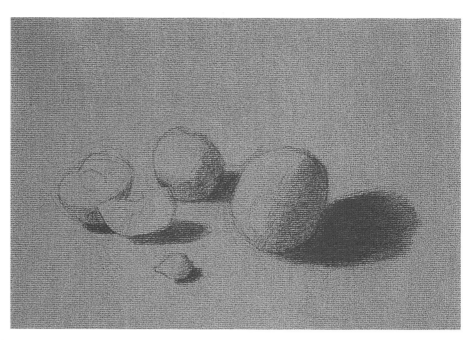

QUICK TiP

You've probably noticed that the parallel-ribbing grain of the charcoal paper is posing a problem in creating a solid tone. That will become less of a problem as you continue to add layers in your revisions.

7 Create the Lights

Create the initial light areas using a trio of yellows, gradually working to the lightest shade. Don't hesitate to mix Violet (a blue-violet), along with Plum and Burgundy (both red-violets), with the yellows to create the midtones. Use the side of the pastel stick, hatch and crosshatch. Don't feel that you must completely cover these areas with one layer.

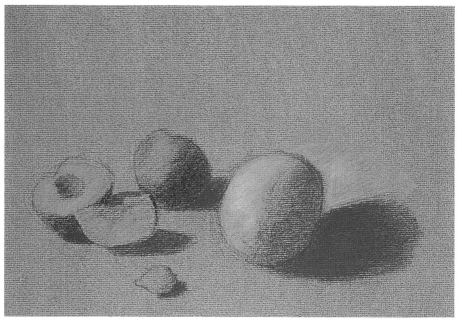

Complementary is Better

Did the neutral gray foundation affect the color you applied? You can always add more layers to gradually cover and replace the gray. You can also adjust your colors with white.

Unless it's absolutely necessary, don't use black—black dulls the color to the maximum degree. If you have to darken the value of the yellow, add hatchings of violet and see if that does the job. Semineutral colors are much more beautiful than colors with black added to them.

Notice that when I applied black to the pure green on the left side, the mixture lost a lot of its color identity and vitality. Adding red, the complementary color, to the green on the right, retains the beauty and vitality of the hue.

with black with the complement

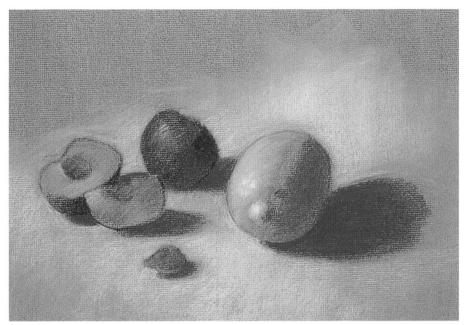

8 Add More Layers

Add more layers to both the light and dark areas to make your statement a little stronger.

If you add a color you aren't happy with or if one color dominates, you can always neutralize it with its complement. Such is the case of the background color around the lightest yellow in this step. If your drawing looks too yellow right now (as my drawing did), layer a little Violet (dark value) and white on top of the yellow. That should neutralize the yellow and move it back towards a light neutral gray.

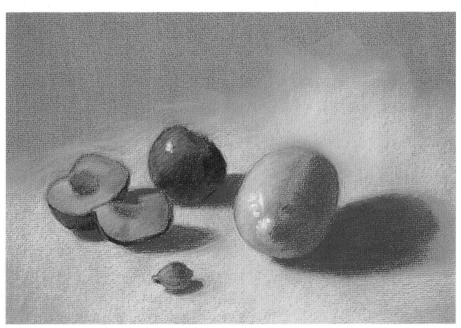

9 Be Patient

The drawing has increased in content and solidity and will continue to do so with each revision and layer. Continue to layer in values until they match what you see in the still life. Remember to hold off on the detail until there isn't anything else to add.

You've gotten to this point without using any black—only yellows, violets, white and all their combinations. Now hatch a little black into the darkest shadow areas to darken the values and to further reduce the evidence of color in the shadows.

QUICK TIP

Always match the darkest value as closely as possible. Squint to compare the values in your drawing with the still life. Continue comparing and revising the drawing until your darkest value matches. This is important because you'll compare all your other values to this dark value. If it is correct, all the other colors should be correct.

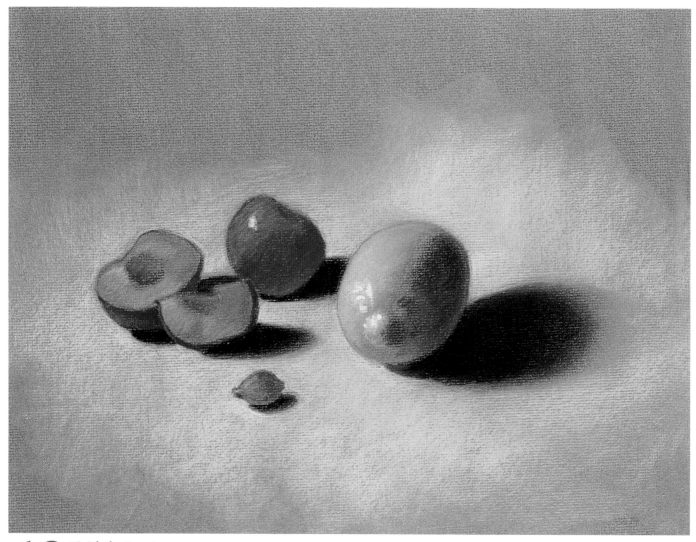

10 **Finish the Drawing**

Add black to the shadow areas and then hatch a layer of Violet on top to retain the yellow-violet complementary color scheme. The resulting shadow mixture will be a dark violet.

A note about the cast shadow: the shadow edge is sharpest near the object casting the shadow and becomes progressively softer as the distance from the object increases. Rub to soften the outer edges. Carefully study the still life in front of you, then draw exactly what you see. Look at and study your subject matter—that's where you'll find all the answers.

Another layer or two should be enough to finish the drawing. This is the stage when you should add subtleties and details.

SWEET AND SOUR
Pastel on charcoal paper
18" x 24" (46cm x 61cm)
Collection of the artist

QUICK TIP

✐ Reworking the drawing over and over is always a plus. You develop more control by adding layers, rather than trying to finish it with one layer.

✐ Basing a drawing on complementary colors creates harmony throughout.

Pastel on Canson Mi-Teintes

You will be using Steel Gray Canson Mi-Teintes paper for your drawing surface. Remember to use the soft (untextured) side. If not sure which side is which, make a side-stroke mark with a contrasting color in the corner of each side. Compare the two, and choose the side without the texture (see page 52). To conserve paper, cut the sheet in two. Let's review a few things we've learned about working with pastels.

✐ Colors you applied on white charcoal paper were darker in value than the paper, so you couldn't tell the true value of the drawing until you established your initial color base.

✐ Working on a nonwhite, neutral color ground is much easier than and preferable to working on white paper.

✐ With a medium-gray paper, colors appear lighter or darker than the value of the paper, so it is much easier to gauge the value of each hue.

MATERIALS

PAPER
Canson Mi-Teintes, no. 431, Steel Gray or a comparable pastel paper

Cold Medium Gray
Selection of yellows, yellow-greens, yellow-oranges and their complements
White
Black

PASTELS
Warm Medium Gray

WORDS TO KNOW

ANALOGOUS COLORS
Colors next to each other on the color wheel.

Analogous Colors
We'll use analogous colors for the next drawing: yellow-orange, yellow, and yellow-green. Analogous colors are those next to each other on the color wheel.

QUICK TIP

When using a paper that is available in a variety of colors, it is helpful to select the same color that dominates your composition or setup. For example, use a green paper for a forest landscape.

Middle Value
Create the contour lines with either Cold Medium Gray or Warm Medium Gray. As you can see, their value is very similar to the value of the paper. You can see the line, but you can also easily hide it. Notice that when you compare the paper value and the two gray pastel sticks to the value scale, they all are somewhere in the middle of the scale. Now, when you apply a color to the paper, you can tell if it's above or below middle value. This will help you select the right color and the right value.

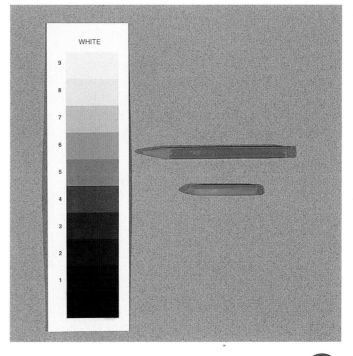

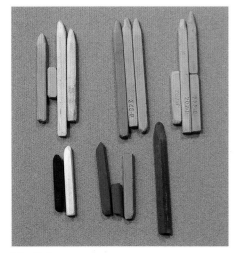

My Colors
Here's my selection of yellow, yellow-greens and yellow-oranges. I'm also including white and black in case I need them to lighten or darken the values. I may not need to use black.

QUICK TIP

- Always indicate a specific light direction in your work and keep it consistent throughout the drawing.
- Check the end of your finger before blending a color area. Dirty fingertips will sully the color.

A

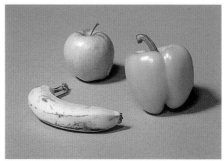

B

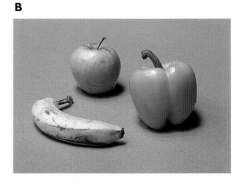

Light Source
Use natural light as your light source with the dominant light coming from one specific direction only. Covering all but one window produces a single form-building light source and lovely cast shadows. Remember to cover up all windows except one and to turn off all other light sources.

Notice the flat lighting and multiple shadows in photo B. The arrangement in photo A, with all but one window covered, exhibits improved value transitions and singular shadow shapes. Notice that the side plane of the banana is definitely a darker value. Look closely for other changes.

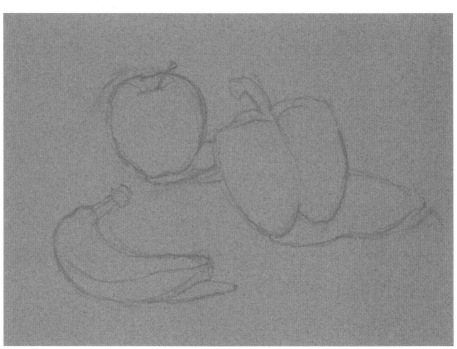

Begin the Contour Drawing
Pick a gray pastel color that is slightly darker than the paper value (such as Cold Medium Gray) to create your contour line drawing. Use light pressure and a sharpened point. Draw the shapes, paying strict attention to the size of the spaces (openings) between the objects.

Don't fret over your contour drawing. If you make a mistake, you can erase it with the kneaded eraser or simply cover it up with another gray color from your set that closely matches the color value of the paper. All the colors that go into creating your drawing eventually will conceal the contour lines.

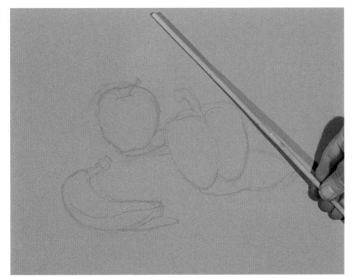

Check the Cast Shadows
To check the position and length of a cast shadow on your drawing, line up a straightedge beginning at the far end of the cast shadow (opposite the light source) and rest the other end on the contour edge of the object. The straight line should point exactly at your light source. Check all the other cast shadows using the same procedure to make sure that they are all pointing to the same light source. Adjust the length and direction of the cast shadows until the guide lines are correct.

WORDS TO KNOW

CAST SHADOW The shadow thrown by an object onto a surface in the opposite direction from the light source.

QUICK TIP

- Rubbing the underneath layers eliminates the grain in that area and renders the area passive and receptive to future changes. Rubbing dulls the pastel, but that's okay because you're going to add layers on top. You don't want to rub the top layers unless you're doing it for a specific reason, such as softening an edge.
- Drawing from reality is the best teacher as it trains you to see, think and make decisions.
- Keep your pastels sharpened so you can be more accurate when hatching and crosshatching. Vary the direction of the crosshatching, and the initial lines will disappear into a tonal mass. Control the slow progress of the drawing and use a delicate touch, just barely changing colors and values.

2 Layer the Foundation Colors
Start building the form by laying in dark and light foundation colors. Remember, this is the simple beginning—you're just lightly indicating colors and values without committing to the color.

Notice the difference in the grain of this paper. Eventually the grain will disappear with all the layering and revisions.

This is the first layer, so keep all your colors inside the contour lines.

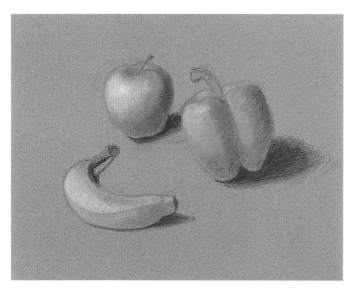

3 Evaluate the Foundation and Add More Layers

Evaluate the initial color statement. If the grain of the paper causes a specific area to appear too light, such as the dark side of the pepper or apple, add more pastel to fill in the grain. Additional layers will gradually eliminate the grain, as will blending with your fingers, a tortillion or a stump.

Evaluate again and then revise and reinforce the drawing with a second layer. Occasionally you may need to draw back into an object with the same gray you used to create the original contour lines.

Keep the development stages simple and gradually work on creating light, volume and depth. Don't be in a hurry; patience is the key.

WORDS TO KNOW

SCUMBLING Lightly applying opaque colors over other colors.

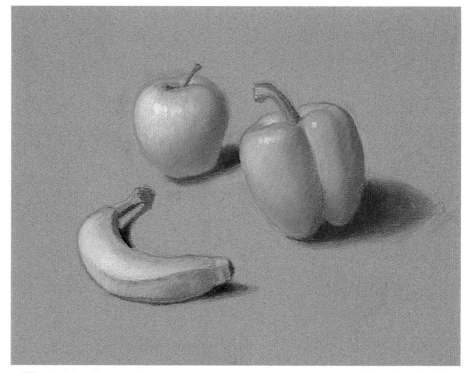

4 Add the Illusion of Space and Depth

After you've achieved the basic forms and colors, continue to develop the front object. Look carefully and describe everything you see. Then, add the details. By this time, the foreground object should be far more developed than the others and will appear to come forward.

Now, look at the next closest object and add some description and detail—but not to the degree of the foreground object.

Don't add any detail to the background objects. Reduce and/or eliminate any evidence of grain around the outside perimeter and soften the contours.

Notice the illusion of space and depth that you have now created. The object in the foreground is fully developed, the middle ground is partially developed and the background area is hardly developed at all.

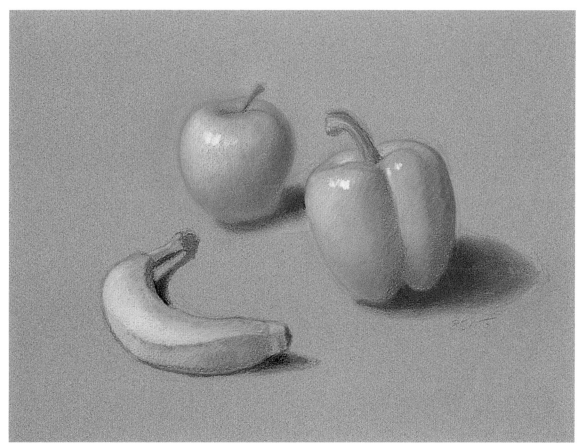

5 **Soften the Apple to Finish**
Soften the apple's contour by rubbing the edge lightly with clean fingers. You may have to repeat this a number of times until it is soft enough—this will further help to create the illusion of space. Try to diminish any evidence of the paper grain. The grain of the apple should be much softer than the others. Since the pepper is a middle-ground form, soften its edge, but not to the extent of the apple. Leave the banana untouched.

DIETER'S LUNCH
Pastel on Canson Mi-Teintes paper
16" x 20" (41cm x 51cm)
Collection of the artist

QUICK TIP

✏ Rub gently with a clean finger to soften edges, contrasts or colors. Rubbing dulls the hue, which makes the color and edge recede.

✏ Another method of softening edges is scumbling. Wipe a pastel stick with a soft tissue to clean it, then lay a side-stroke over the hard edge of your drawing. Each stroke will start to blend and soften the edges underneath.

Working From a Photograph

Up until now, we've been working from reality, which is best. Working outside in *plein air* should be a future goal and one that I highly recommend. Before venturing outside, however, you need time to further grasp the fundamentals and gain more drawing experience. So the next best thing is to use photography for landscape drawing.

Before we begin our landscape drawing, let's discuss the pros and cons of using photographs. Artists do create drawings from photographs, and have long used them as a reference source.

The Camera

Think back to the discussion of how your eye sees on page 82. The camera lens does not see exactly the same way we see. The camera lens distorts the view that we see with our eyes and generally flattens the composition (foreground, middle-ground and background), making everything equally focused. As a result, the camera takes this clear focus area, called the *depth of field*, and visually compresses everything into a flat plane. Therefore, as an artist, you must use what you have learned about creating the illusion of space to interpret the photograph and create the image you want, rather than copying the photograph exactly.

Dyes used in film development do not accurately reproduce the colors found in nature. Your eyes are better at seeing and recording hues. Color film doesn't record the entire range of values in bright sunlight—it records only about two-thirds of the value scale. Either the lighter values flatten out to white or the lower values flatten out to black. Check some bright, sunlit photographs to see the convincing evidence.

Another important point: always work from photographs that are at least 8"x 10" (20cm x 25cm) in size—large enough for you to clearly see details.

Anything smaller is difficult to work with.

Remember, the camera lens distorts our perception of reality and the film development process distorts colors, temperatures and values. It's important to understand photography's limits and to use photos only as reference tools, not as something to be copied exactly. Be careful not to let photography become a crutch.

WORDS TO KNOW

PLEIN AIR An expression used to describe the practice of painting outside in the open air in order to study and describe the effects of light and atmosphere.

Pastel on Sandpaper

For the final drawing demonstration you are going to use a new pastel surface, sandpaper. There are a number of different types of sandpaper surfaces made for pastels. Choose a neutral color for this drawing.

Since a sheet of sandpaper costs three to five times more than Canson Mi-Teintes paper, you might want to work on a half sheet. Crease your paper in half and tear or cut on that line.

MATERIALS

PAPER
Neutral sandpaper for pastel

PASTELS
Your pastel set

OTHER
Blue painter's tape
Fixative
Tissues or paper towels

QUICK TiP

In the blocking-in stage, make sure your colors are dark and intense, perhaps a little darker than you think they should be. Stay away from the light colors as long as possible, and stay in the loose stage equally as long. This helps you to progress slowly through the development stages.

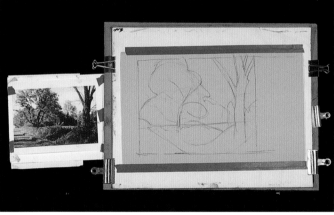

1 Begin With a Contour Drawing
To help you place objects properly, I suggest you start by drawing an outside line that is proportionate to your 8" x 10" (20cm x 25cm) photograph. In my case, 11" x 14" (28cm x 36cm) is proportionate. Attach blue painter's tape (easily removed later without damaging the paper) a half inch (12mm) outside this boundary. This makes it easier to calculate the placement and proportions of shapes within the box. (You'll completely surround your picture area with the tape in the later sequences.) Place your photograph next to your drawing surface and begin with a loose contour line drawing using a brown pastel.

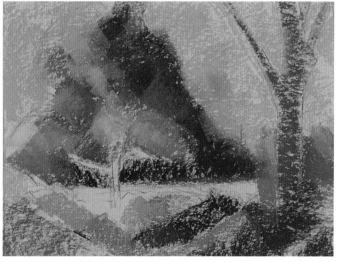

2 Block In the Color Shapes
Start blocking in the general color shapes. Just take a stab at the color and values and block them in with a bold sidestroke. This is the initial base and will be changed a number of times.

As you block in colors, you visually and physically experience the grain of the sandpaper surface. It's different from all the other papers you've used so far. We'll get rid of that grain.

3 Eliminate the Texture

Rough texture tends to come forward in a drawing. Rub with a tortillion or stump to eliminate the texture and create a solid block of color, being careful to retain the color purity of the shapes you've just blocked in.

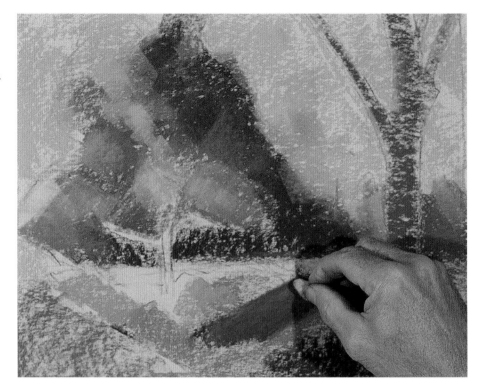

4 Evaluate Your Foundation

Once all the areas have been blended, evaluate what you have. Remember, you're concerned only about color shapes at this point, nothing else. By blending your base colors you got rid of that pesky texture, so you should now have a better idea of the colors and values.

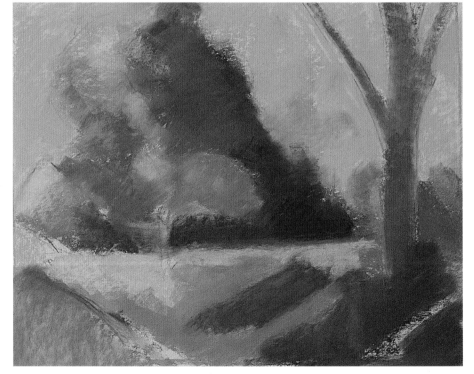

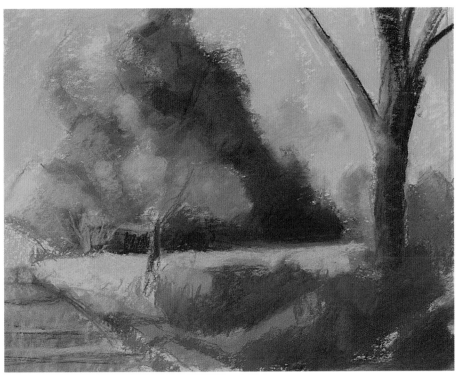

5 Continue Applying Color

Work very loosely as you continue to develop the correct base colors and values. Don't be afraid to make mistakes—that's how we learn best!

Work with the side of the pastel and generalize as long as possible. The light in the photograph is coming from the left side; keep that source consistant throughout the drawing.

Remember, you're trying to create an illusion of space. Tighten up in the foreground but leave the background loose. Try to create a middle-ground transition between the two.

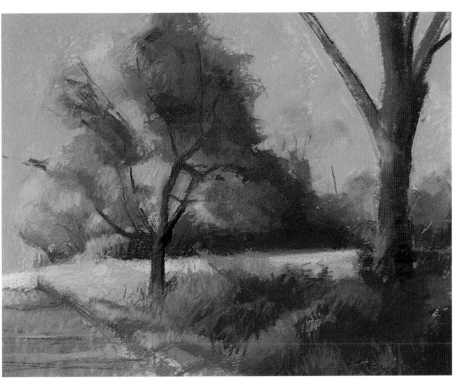

6 Search for Pattern and Movement

Keep the drawing loose and search for pattern and movement, squinting as you go. It's still too early to add any detail. Be patient during the drawing's different stages as layers of color are applied over each other. As you shade and highlight, the shapes will begin to take form and will appear to have volume.

Continue to evaluate whether each area is the correct value and revise as needed. Are you starting to see a landscape?

7 Revisit Every Area and Begin to Add Detail

Work more on the dark and light patterns in the foreground and start making individual descriptive marks. Be sure to vary the strokes. Keep the background minimal and you'll begin to create the illusion of space.

Revisit every area, adding more and more color as you go. Begin to concentrate on the foreground and describe the vegetation.

QUICK TiP

- Clean the surface and point of your pastel stick often with soft tissues or paper towels. When you make a mark with pastels, the sticks pick up color from the drawing surface. Without cleaning, they will redeposit that picked-up color back on your drawing with every stroke, dulling your hues.
- Store your colors in an orderly fashion (yellows together, oranges together, reds together, etc.).
- A pastel drawing needs to be protected. One way to do this is to spray the drawing with fixative.

8 Add the Final Touches

The key to finishing is perseverance. The beginning stages are relatively fast and direct but the final ones are slow and deliberate, taking more thought, more planning and countless revisions.

Stand back from your work often to view your drawing from a distance. Make sure the direction of the light is consistent, and that you're building the foreground while still retaining value, patterns, movements and color contrasts.

I think you can now understand the reason for building a darker foundation than you thought you should. Without a dark foundation, the individual lighter foreground marks would not be visible. Speaking of those individual marks in the foreground, remember to vary the size, width and pressure of the marks. Variety is interesting; overly repetitive strokes are boring.

Make sure you continue to use your lightest, warmest and brightest colors on the side facing the warm light source. Use semineutrals and neutral grays on the shadow side.

Also, remember to soften edges, reduce color contrasts and minimize in the background; the foreground should have the most detail, defined edges and strongest color contrasts.

DOWN A COUNTRY ROAD
Pastel on sandpaper
11" x 14" (28cm x 36cm)
Collection of the artist

Conclusion

Congratulations! You've completed all the exercises in the book and you're well on your way to learning how to draw. That's quite an accomplishment and you should be proud of yourself.

However, learning how to draw is like opening a bottomless treasure chest: it's a wonderful, life-long experience.

Let's go over some of the points we've covered. You've learned:

- basic techniques
- about procedures and drawing methods
- about color
- about lighting
- about different drawing surfaces
- how to apply, erase and blend each medium
- how to experiment and revise
- how to think like an artist
- that drawing is a skill that you can acquire and improve upon with practice
- that creating good art takes time, effort, diligence, patience and perseverance

Good luck and best wishes for future success in art and life.

Larry Blovits

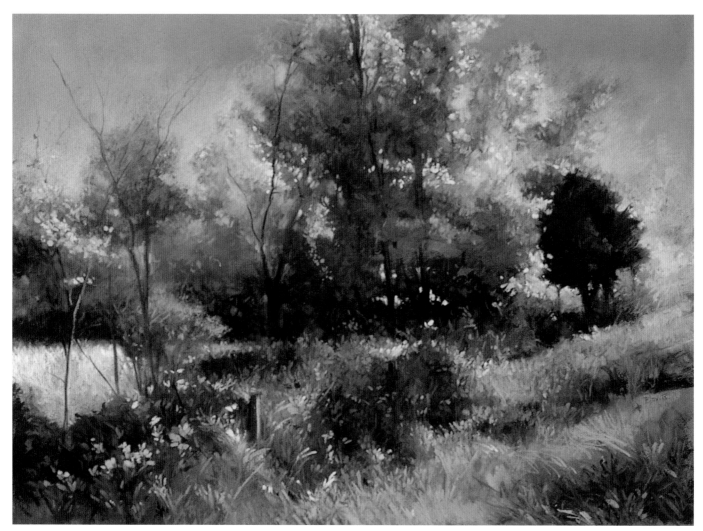

FALL EXPLOSION
Pastel on Canson Mi-Teintes paper
19" x 25" (48cm x 64cm)
Private collection

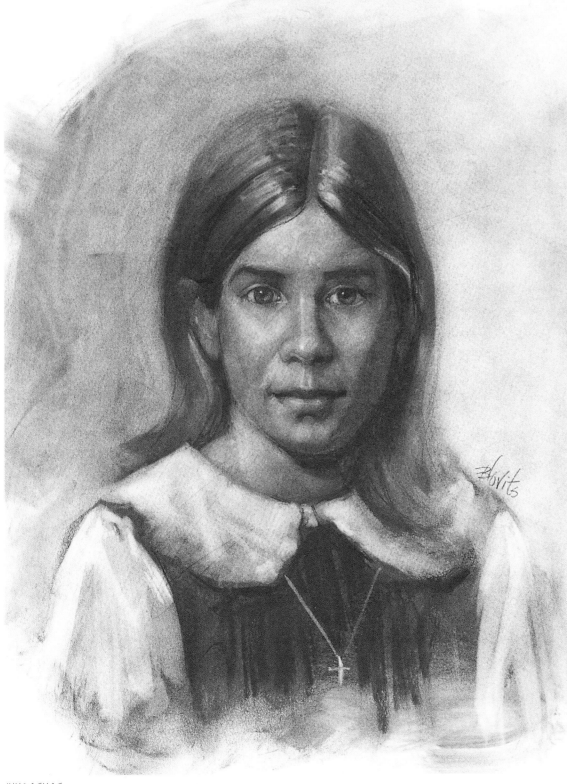

This is a charcoal demonstration I did at the American Society of Portrait Artists seminar in Montgomery, Alabama. I picked drawing paper as my surface for this study of a beautiful child.

INNOCENCE
Charcoal on drawing paper
24" x 18" (61cm x 46cm)
Collection of the artist

Glossary

Achromatic Possessing no hue; having to do with white, black or gray.

Aesthetic Range The variety of marks made by each pencil type that are the richest and most beautiful.

Additive Process The method in which a medium is applied to the paper in successive layers to create the drawing. There is no erasing.

Additive-Subtractive Process The method in which a foundation value is established to cover the white of the paper, after which the drawing is produced both by lifting and erasing to expose the white of the paper in various degrees of translucency, and by adding additional values or colors.

Analogous Colors Colors next to each other on the color wheel.

Application Pressure How hard or how lightly you push on the drawing tool when creating a line or tone.

Blending The process of smoothing and combining pencil marks or other mediums to create variations or gradations in value.

Blind Contour Drawing A contour line drawing done without looking at the paper or lifting the pencil while drawing.

Bridge A piece of paper or another material placed between the hand and the drawing surface to keep the drawing clean and prevent smudging.

Burnishing Heavy rubbing that completely flattens the surface texture.

Conté Crayon Invented in 1795 by Nicolas Jacques Conté, the drawing medium is a mixture of compressed pigments, clay and a slightly greasy binder.

Cast Shadow The shadow thrown by an object onto an adjacent or nearby surface in the opposite direction from the light source.

Chamois A soft, clothlike leather used to remove or blend drawing materials such as charcoal, pastel and Conté.

Composition The organization of the physical elements in a work of art; the arrangement of shapes, forms and masses.

Complementary Colors Colors that are opposite one another on the color wheel; for example, blue is the complement of orange.

Contour Lines Outlines or defining edges.

Compressed Charcoal Charcoal sticks or pencils made denser and darker than vine charcoal.

Cross-Contour Lines Real or imaginary lines on the surface of an object that indicate direction and structural form.

Crosshatching Similar to hatching, except the lines cross each other to create a different set of marks. Use it to increase density and darken values.

Diminution Occurs when objects of equal size appear smaller as they recede into the distance.

Flat Value Consistent value within a specific area.

Form The three-dimensional quality of objects in a drawing or painting.

Fixative A spray that provides a transparent protective coating over a drawing to shield it from smearing or damage.

Gesture Line Drawing A quick line drawing that indicates energy or motion rather than specific form.

Graphite Stick A piece of solid graphite without an outer covering, used for drawing.

Graphite Shine The indentation and shine that appears on a surface when too much pressure is applied for a particular pencil lead.

Hatching A series of lines, usually parallel, placed close together and used to build shape, texture or shadow.

Halftone The value in a drawing that is midway between the lightest and darkest value.

Highlight The lightest value found on the brightest portion of an object on the side receiving the most light.

Hue The common name of a color, such as red or blue.

Inside Edge Any edge or border found within a form.

Intensity The degree of saturation or brightness of a color.

Kneaded Eraser A pliable soft eraser that is very safe for drawing surfaces.

Monochromatic Having, or perceived as having, only one color.

Neutral Gray A color produced by mixing two complementary colors together in equal amounts in order to cancel out the identities of the components.

Outside Edge The line, border or contour that defines the silhouette of an object.

Picture Plane The defined area on which the artist creates the pictorial image.

Plein Air An expression used to describe the practice of painting outside in the open air in order to study and describe the effects of light and atmosphere.

Primary Color A hue that cannot be created by mixing any other colors; red, yellow and blue are primary colors.

Reduction Occurs when details fade as objects recede into the distance.

Reflected Light The relatively weak light that bounces off a nearby surface onto the shadowed side of a form.

Rubbing Blending with enough pressure to flatten or damage the tooth of the drawing surface.

Sandpaper Block A portable device used to resharpen a pencil to a finer point while the drawing is in progress.

Scumbling Lightly applying opaque colors over other colors.

Secondary Colors Colors created by mixing two primary colors. For example, yellow and red make orange, red and blue make violet, and yellow and blue make green.

Semineutral A color mixed with its complement that retains its color family identity although its intensity has been reduced. For example, a dull yellow is still recognized as being in the yellow family.

Shape A flat area with a particular outer edge, or boundary.

Squinting The practice of looking at objects with half-closed eyes so as to focus on values and eliminate details and colors.

Still Life Inanimate objects used as subject matter, not to be confused with a landscape or figure.

Stump A blending tool made of compressed paper.

Subject Matter Items represented in an artwork, such as a landscape, portrait or still life.

Subtractive Process The method in which a foundation value is established to cover the white of the paper, after which images are produced by removing medium to expose the white of the paper in various degrees of translucency.

Surface Grain or Texture Differences in paper surfaces from smooth to rough.

Temperature The relative warmth or coolness of a hue.

Tone (Tonal) Values between white to black that convey volume, lightness and darkness.

Tooth The intrinsic texture or grain of the drawing surface.

Tortillion A rolled and tapered cylinder of soft paper used to blend edges or soften textures.

Transition The gradual or sequential change from one state to another.

Translucent The quality that allows the white of the paper to remain visible through tonal layers.

Unity The evident, overall relatedness of the elements of a work of art.

Value The relative lightness or darkness of a color, tone or shade.

Value Scale A tool that indicates gradations of tone from the lightest to the darkest.

Value Transition A progression from dark to light or light to dark.

Vine Charcoal Charcoal made from carbonized wood.

Volume The three-dimensional quality of a form existing in space.

Index

The best in fine art instruction and inspiration is from North Light Books!

A complete course in drawing, *Drawing People* focuses on the clothed person as opposed to the nude figure. Author Barbara Bradley takes a friendly approach to teaching the fundamentals of drawing people—proportion, perspective and value. You'll also learn how to draw different clothing, how you can use folds in your drawings, and how to draw clothing on people. Included are tips for drawing heads and hands accurately and special instructions for drawing children.

ISBN 1-58180-359-1, hardcover, 176 pages, #32327-K

Bestselling author Lee Hammond is known for her clear, basic methods for drawing nearly any subject. This giant book brings together the best projects from her other titles into one super-sized guide! You'll find complete step-by-step instructions for drawing popular subjects including people, animals, flowers and nature. You're sure to find creative success with Lee Hammond leading the way!

ISBN 1-58180-473-3, paperback, 240 pages, #32741-K

Bert Dodson's successful method of "teaching anyone who can hold a pencil" how to draw has made this tome one of the most popular, best-selling art books in history—an essential reference for every artist's library. Inside you'll find a complete system for developing drawing skills, including 48 practice exercises, reviews and self-evaluations.

ISBN 0-89134-337-7, paperback, 224 pages, #30220-K

A sketchbook journal allows you to indulge your imagination and exercise your artistic creativity. Let Claudia Nice provide you with invaluable advice and encouragement for keeping your own. She reviews types of journals along with basic techniques for using pencils, pens, brushes, inks and watercolors to capture your thoughts and impressions.

ISBN 1-58180-044-4, hardcover, 128 pages, #31912-K

These and other fun North Light books are available from your local art & craft retailer, bookstore, online supplier or by calling 1-800-448-0915.